IMAGES
of America

SORRENTO,
MOUNT PLYMOUTH,
AND
EAST LAKE COUNTY

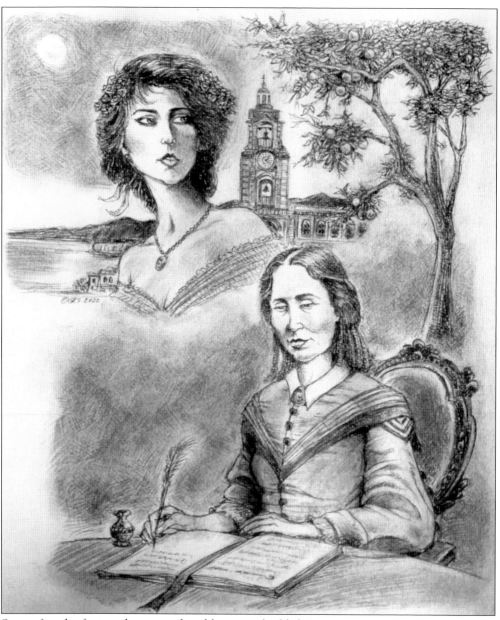

Soon after the first settlers arrived and began to build their new community, they wanted to give it a name; however, they could not agree on any specific one. At this time, the settlers were enjoying the novel *Agnes of Sorrento*, written by Harriet Beecher Stowe. Sorrento became a popular choice, but to be fair, they decided to place the various suggested names into a hat and have a blindfolded person draw a name. Sorrento was chosen. (Courtesy of artist Gary Schermerhorn.)

ON THE COVER: This 1913 photograph features the students at Sorrento School preparing to embark for Tavares for the inaugural school fair held in Lake County. Students from schools throughout the county attended. The first school fair building in the United States was constructed in Tavares through the influence and efforts of traveling teacher Flora H. Brown. (Courtesy of East Lake Historical Society.)

IMAGES
of America

SORRENTO, MOUNT PLYMOUTH, AND EAST LAKE COUNTY

Bob Grenier and
the East Lake Historical Society

ARCADIA
PUBLISHING

Published by Arcadia Publishing
Charleston, South Carolina

Printed in the United States of America

Library of Congress Control Number: 2022949275

For all general information, please contact Arcadia Publishing:
Telephone 843-853-2070
Fax 843-853-0044
E-mail sales@arcadiapublishing.com
For customer service and orders:
Toll-Free 1-888-313-2665

Visit us on the Internet at www.arcadiapublishing.com

Bob, Shirley, and Maggie dedicate this book to the indomitable spirit and courage of the settlers who pioneered East Lake County—and to those who followed.

CONTENTS

ACKNOWLEDGMENTS

When I moved to Mount Plymouth in 1985 from Illinois, I became well-acquainted with the residents of the Sorrento–Mount Plymouth area because I was an air-conditioning repairman—a skill that came in quite handy in the Sunshine State. Through the years, having become involved in historic preservation, museum curation, and authoring books about Central Florida history, I reconnected with the East Lake County residents when the East Lake Historical Society was established. The society's membership has opened their homes and hearts and have shared their memories with me. This photographic journey through East Lake County was made possible by the following people for whom I am truly grateful: Maureen Miller, Caroline Austin, Shirley Grantham, Catherine Hanson, John Jackson, Dixie Royal, Donna Bowers, Richard Royal, Don Philpott, Kathy Horton, Martha Whitley, Pat Musselman, and all the people and businesses whose photographs are featured in this book. Everyone worked diligently to identify faces from long ago and to spell the names correctly.

There are many outstanding organizations to thank, including the Lake County Historical Society, Camp Challenge, Camp Boggy Creek, Cassia Community Club, Wekiva Wilderness Trust, Florida State Parks, State Library and Archives of Florida, Bonnie Whicher Photography, East Lake County Chamber of Commerce, East Lake County Library, and the East Lake Historical Society.

Publications were a great resource. *Agnes of Sorrento* by Harriet Beecher Stowe; *The Amazing Story of Ethel, Anthony Frazier, and William S. Delk* by Don Philpott and Shirley Meade; Prof. William Kennedy's *History of Lake County*; the *Mount Dora Topic*'s interview of Miss Hattie Allen; authors Emmett Peter and Richard Lee Cronin; and newspaper columnists Ormund Powers, Ramsey Campbell, and Rick Reed. My appreciation to Arcadia Publishing and to artist Gary Schermerhorn.

Thanks to East Lake County librarian and East Lake Historical Society founder Scott Amey. A special thank-you to Tavares Public Library reference librarian Marli Wilkins-Lopez for her research, editing, and proofreading.

My profound gratitude to East Lake County historians Shirley Meade and Maggie Fisher. Both of these gracious ladies were up to the challenge, day after day, of collecting the photographs and supplying the history I needed to write this book.

This book was made possible by the support and encouragement of my parents, Mary and Bob Grenier; Alma N. Grenier; and God.

All images appear courtesy of the East Lake Historical Society unless otherwise noted.

INTRODUCTION

Traveling east along State Road 46 from the popular tourist city of Mount Dora, you quickly come upon the small town of Sorrento. In addition to being the western gateway to some of the most beautiful and exotic conservation land in Florida, Sorrento has a history as unique and intriguing as any of its larger neighboring cities.

In 1875, ten years after the conclusion of the War Between the States, a major migration from the cold North, as well as many families from North Carolina, South Carolina, and Georgia, traveled to the eastern frontier known as Florida. In the great lake region of West Orange County, located in the heart of the state, an emerging settlement called Sorrento was established. The families who arrived planted orange groves—getting their seedlings from former slaves of the William Delk plantation, who lived in the vicinity.

The residents formed the Sorrento Immigration Society to promote their community. Albert Matlack, one of five bachelors who arrived from Ohio, wrote:

> Health and home in the land of the orange and magnolia are within reach of all who suffer from the ills consequent of a rigorous climate. There is no healthier locality in Florida than the high rolling lands lying between Sorrento and Lake Dora. From 100 to 300 feet above the level of the sea, and fanned by the cooling breezes from both the Gulf and the ocean, the air is pure and invigorating. Land is yet low in price and plenty to choose from. Nowhere does the orange attain greater perfection or grow with greater luxuriance. Three railroad companies have projected lines through this beautiful country, and we confidently expect that some of them will be pushed to speedy completion. The first to apply will have the finest lands to select from and the lowest prices to pay.

A steady stream of homesteaders continued to arrive into the next decade as more people traveled the boat line from Jacksonville to Astor on the St. Johns River and then by railroad to Fort Mason, where they rode horse-driven wagons to Sorrento. In 1886, Phillip Isaacs, the publisher of the *Florida Highland Press*, included advertisements in his publication that stated, "Today there is not a better point in the State of Florida for health and home seekers. Sorrento and the large body of rolling pine on all sides of it is acknowledged, and has been proven to be, a health resort in the true meaning of the word."

A short distance from Sorrento lived a powerful attorney named Maj. Alexander St. Clair-Abrams. He had established the city of Tavares in 1880 and had big plans to make Tavares the new capital of the state. But first he needed to create a new county. In the spring of 1887, following months of surveying and mapping, St. Clair-Abrams brought his conception of a new county to Tallahassee. Within the boundaries of the proposed county was Sorrento. By this time, the Sanford & Lake Eustis Railway made a stop in Sorrento and continued west to Tavares. The railroad, along with a flourishing Sorrento, was a huge factor in St. Clair-Abrams's plans. However, the folks of Sorrento were not eager to participate. On June 1, 1887, five days after the Florida legislature approved the formation of the new county called Lake, there appeared a special correspondence in the *Times-*

Union in a section called the "Sorrento Dots" that told of the Sorrento citizens' displeasure over leaving Orange County—but also of their submission for accepting the inevitable. Sorrento went on to become, in the proud words of Hattie Allen, granddaughter of Sorrento pioneer William Allen, "A Happy Community with Prosperity!"

After you complete your tour of Sorrento, continue your journey east along State Road 46 where you will come upon a picturesque village in the hills that gives the impression of a Currier and Ives painting come to life. During the Florida land speculation of the 1920s, the rolling green hills that adjoined Sorrento prompted a group of wealthy business and sports figures to form a company called the Mount Plymouth Corporation. These prominent men included developer H. Carl Dann, baseball legend Connie Mack, real estate operator Edward Carney, newspaper magnate Graves Whitmire, and John Pirie, cofounder of Carson Pirie Scott and Company department store.

The corporation began to develop a 5,000-acre parcel that included the Pirie cattle ranch, known as the Over the Top Ranch. The dream was to build a winter resort community reminiscent of the Scottish countryside and Scotland's celebrated St. Andrews Golf Club. In December 1926, they opened the 150-room Mount Plymouth Hotel and Country Club on Dubsdread Drive. Several promotions billed their newly planned resort and sports community as "The Golf Capital of the World" and "Florida's Playground City."

During this same period, architect Sam Stoltz designed several Storybook homes in Mount Plymouth. In describing this style of architecture, Stoltz said, "Nature confines her lines entirely to curves. Mount Plymouth, with its beautiful hills and valleys is full of curves. When we created The Plymouthonian, we followed the teachings of the old masters and modern artists, eliminating the usual harsh lines and produced a type of home in keeping with its surroundings, just as if it grew there—a part of the landscape."

After your memorable stay in Mount Plymouth, you will continue your adventure traveling east on State Road 46 and then north on County Road 46A. This scenic byway will take you to State Road 44 where you will turn and head east. Soon, you arrive at the threshold of the Seminole State Forest and the tight-knit community of Cassia.

With a tradition that began in 1958, the Cassia Community Club is host to Cassia Day—an event alive with music, barbecues, games, crafts, auctions, turkey shoots, and more. The annual celebration honors the town's heritage. Cassia's history began in the 1850s when the first settlers arrived around Blackwater Creek. Early families included the Royals, Griffins, Owens, Boykins, and Thompsons. They grew citrus, raised cattle, extracted turpentine, and logged. By 1879, the close bond that developed amongst the community prompted them to give a name to their settlement. After an assortment of suggestions, a teacher proposed Cassia—a name with Scottish origins as well as the name of a flowering tree and an oil referenced in the Bible.

For the adventurous, you may continue your exploration of East Lake County by hiking, bicycling, or horse-back riding along the trails winding through the pine flatwoods and oak hammocks or by canoeing and kayaking the waterways. Spectacular scenic springs are abundant. At Indian Springs, there is a legend that a fortune in gold coins is still hidden. When a company of soldiers carrying an army payroll during the Seminole War was ambushed at the spring, a quick-thinking lieutenant hid the money in the water to keep the Seminoles from finding it.

The train whistles are now only a sound in the distance and the steam paddleboats have sailed away. There is no longer laughter and singing resonating from the schoolhouses and band shells, and people no longer gather at the church and general store. These are the images of towns that once were. Settlements where the spirits of pioneers past once resided. Among the more than two dozen ghost towns located throughout the East Lake County backwoods, there is a hamlet named Kismet, where the parents of the world's most famous cartoonist were married, as well as the amazing story of Ethel, a lost village in Rock Springs Run State Reserve, where a freed slave and former Union soldier named Anthony Frazier homesteaded and became an Orange County commissioner of roads.

The East Lake Historical Society and I hope these vintage photographs and captured moments in time bring back fond memories and take you on a journey to days gone by!

One

A Town with a Charming Historic Heart

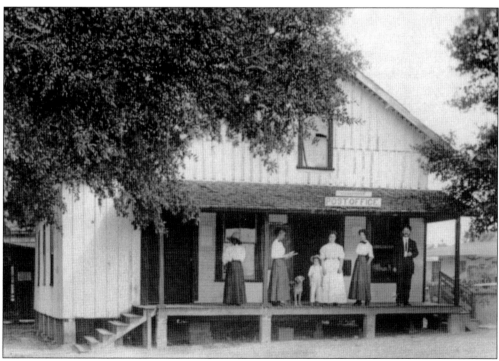

This photographic journey begins at the old Sorrento Post Office. William P. Allen and his son Arthur (right) arrived from Ohio in 1881. After they built their homes, Arthur sent for his wife, Hannah, and three-year-old daughter Hattie May. Hattie is pictured holding mail in this 1910 photograph. Another daughter, Hazel Marie, was born in Sorrento in 1889. Arthur was a clerk for his father's store and became the postmaster in 1909.

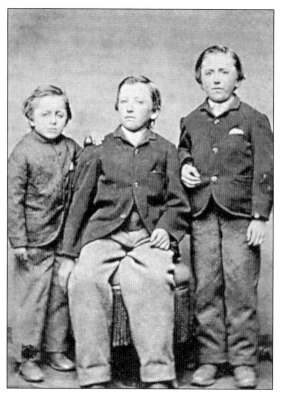

Pictured in this 1860s photograph are, from left to right, Warren, Calvin, and Arthur Butts. They are the sons of Pennsylvania-born William P. and Elenora Butts, who came to Sorrento in 1875 with four of their children, daughters Clara and Ida and sons Calvin and Warren. Butts was a brickmaker and a successful orange grower until their groves were destroyed in the freeze of 1894–1895. Calvin donated the land for the Sorrento Cemetery.

August Hubert Butts, son of William P., was born in Sorrento in 1884. He married Natalie Swanson, and the couple had four children, Jeannette, Clarence, Harold, and Myrtle. By 1920, the Butts moved to West Palm Beach, where they purchased 3,500 acres west of Boca Raton. The family established the Butts Farm, growing primarily beans. The farm became one of Florida's largest employers and produce shippers. Butts passed away in 1955.

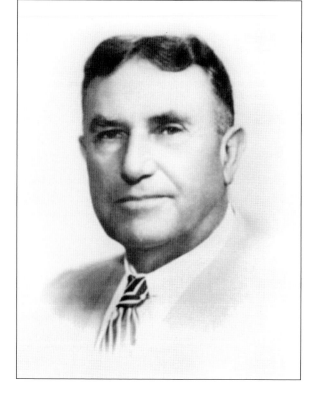

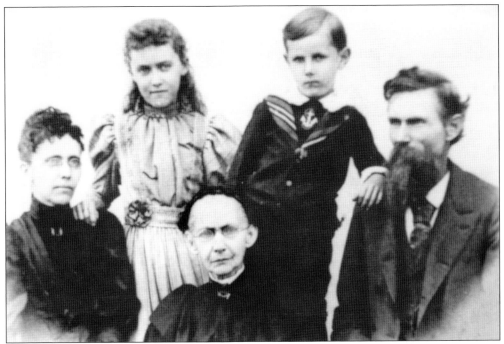

The Matlack family, pictured in this c. 1900 photograph are, from left to right, Rebecca Matlack Brown, Mabel Brown, Mary Ann Matlack, Shelton Matlack, and Albert Sharp Matlack. In a series of letters dated in 1976, Marion B. Matlack, Albert's son from his second wife, Anna Brooks, wrote that his father arrived in the fall of 1875 and homesteaded at Round Lake. He was a merchant, postmaster, orange grower, deputy tax collector for Orange County, and the first station agent under three railroads—Jacksonville, Tampa & Key West; the Plant System; and the Atlantic Coast Line. He was also a surveyor and mapped the main part of Sorrento as well as the Sorrento Cemetery. Matlack, who was born in Fairhaven, Ohio, was sometimes called the "Professor," since he was a graduate of the New York Phrenological Institute. The store Matlack co-owned with Ed Averill is pictured below.

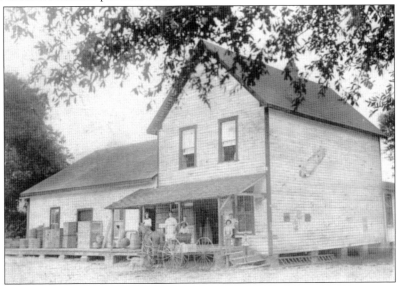

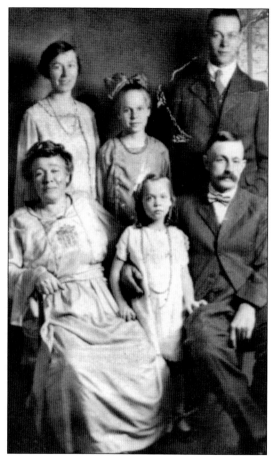

The Lent family pictured in this 1921 photograph are, from left to right (first row) Lena Hegamire Lent, Ethel Lent, and Victor Emanuel Lent; (second row) Elizabeth Lent, Olive Lent, and Adelbert Vincent Lent. Victor and his son Adelbert were citrus growers. In the 1940s, they operated the Lent Packing House where they graded, sized, bagged, and boxed fruit to ship to northern markets by rail. By the early 1950s, their packinghouse went bankrupt, and the building was used for storage. In 1970, the structure burned down. The Lent Packing House was located on a clay road known as Lent Road. The road eventually was paved and renamed Adair Avenue. Pictured below are Joseph William Moore (left) and Adelbert Lent (right) working in the groves.

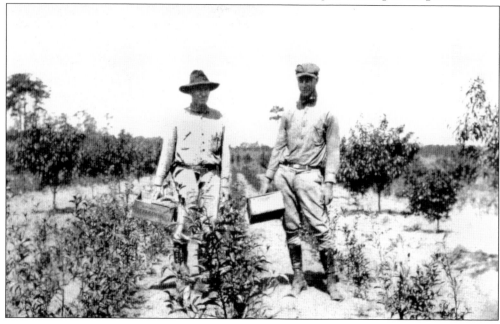

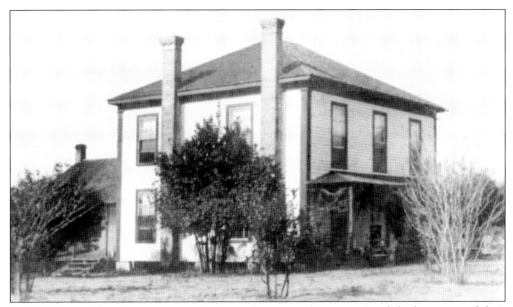

In 1880, Edward Averill constructed this house for new settlers to stay in while they prepared their homesteads. It was the largest house in Sorrento and was known as the Averill House. In 1882, Averill sold the house to Dr. Thomas, a retired physician from Ohio. The house then became known as the Sorrento Hotel. Distinguished visitors included Rose Cleveland, the sister of Pres. Grover Cleveland, and author Isabella "Pansy" Alden.

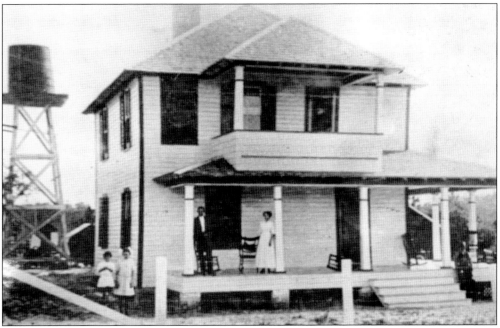

Joe D. Kennedy, standing on the porch with his wife, Lola, in this c. 1880 photograph, arrived in the area as a young boy. The Kennedy home was located on Averill Street (Plymouth Sorrento Road). Kennedy managed the Umatilla Packing Company. Daughters Lela (left) and Mildred (right) are standing in the yard. Kennedy was killed on Rock Springs Road by a wild hog. The East Lake Chamber of Commerce used the house before razing it.

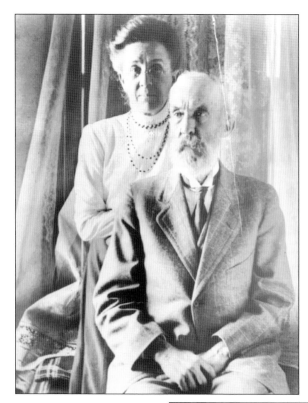

Dr. Ethan Bliss, pictured with his wife, Bertha Brooks, opened the first drugstore in 1886. Ohio-born Bliss, a Union veteran, married his wife on New Year's Eve 1873. Bertha was the sister of Anna Matlack. In 1900, the Blisses lived in nearby Bay Ridge in Orange County. In 1910, they moved to Jacksonville. Dr. Bliss passed away on April 19, 1927, and is buried in the Sorrento Cemetery.

Dr. Howard, pictured sitting in the town's first horseless carriage at the drugstore in 1912, had a lot of mechanical problems with his vehicle when he made house calls. The doctor lived at Martha C. Borden's house at the top of the hill near the Presbyterian church. In December 1915, George Pease arrived from New Smyrna to be the new druggist.

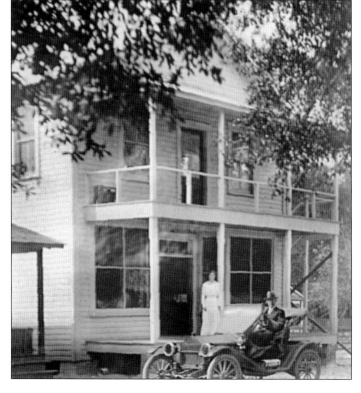

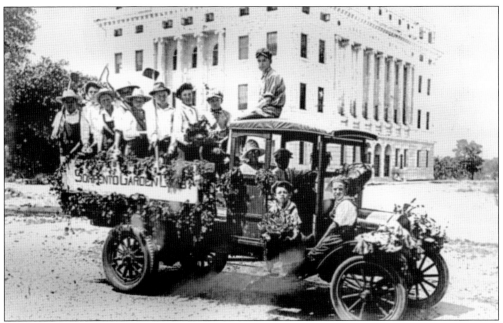

With Sorrento's increasing population growth from the 1880s through the 1920s, the citizens established many social clubs as well as religious and educational organizations usually found in larger towns. In 1883, a village literary society was formed. The society members met at the town hall where they gave organ recitals, book reviews, performed plays, and held bake sales, suppers, and dances. Amongst the most active groups that formed were the Chautauqua Reading Circle, the Sorrento Woman's Club, and the Sorrento Improvement Society, which were tasked with laying out streets and planting oaks. In the 1924 photograph above, the Sorrento Garden Club participates in the opening celebration of the new Lake County Court House in Tavares. The Ladies Church Auxiliary (below) poses at a silver social held on Thanksgiving Day at the Allen residence.

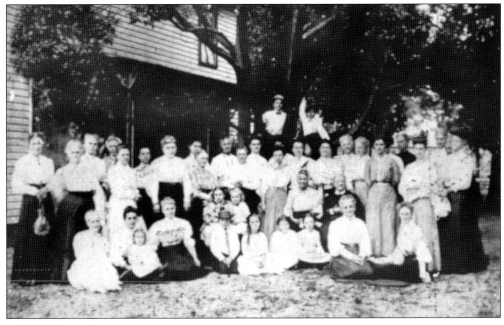

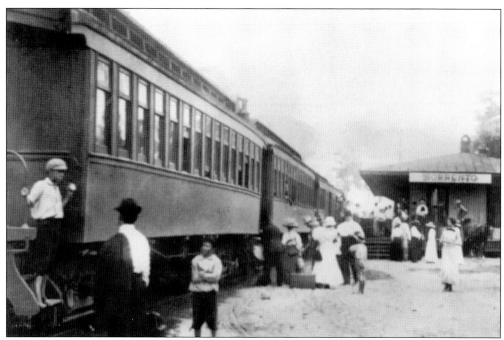

In the early 1880s, Major St. Clair-Abrams organized the Peninsular Land, Transportation, and Manufacturing Company, which was the parent company of the Sanford & Lake Eustis Railway. In 1885, the railroad began laying track in Sanford and completed its 28-mile stretch to Tavares on November 17, 1886. The line made stops in the present-day ghost towns of Sylvan Lake, Paola, Markham, and Ethel. The railroad also served as a branch of the Jacksonville, Tampa & Key West Railway; the Plant System; and later, the Atlantic Coast Line Railroad. The first ride from Sorrento to Sanford was taken by Mary Cooper, Clara Cooper, and Allie Budgeon. The Sorrento station (shown in both photographs) saw two mail trains, two accommodation trains, and several freight trains make stops there daily.

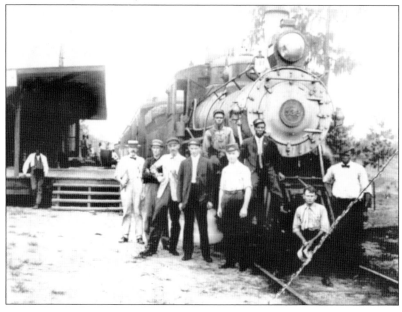

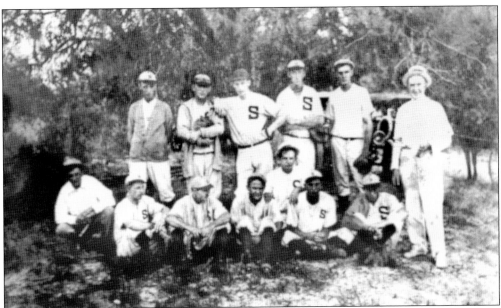

In the late 19th century, Sorrento began to field a "town team" baseball club. The team, sponsored by local farmers and businessmen, barnstormed around the region to compete against teams as far away as Orlando, Ocala, and Titusville. By the late 1880s, baseball had become a national pastime and was very popular in rural America. Competition grew intense among teams in close proximity to each other, and challenges were sent to neighboring towns. By 1910, and for several years after, the Sorrento Baseball Club (above) had one of the most talented teams in the state and was number one in the region. Pep rallies to raise money for the team were highly successful, with "fun-raising" events that included ice cream socials and carnivals. The Sorrento Baseball Club and fans (below) board the Atlantic Coast Line's "Sorrento Baseball Special."

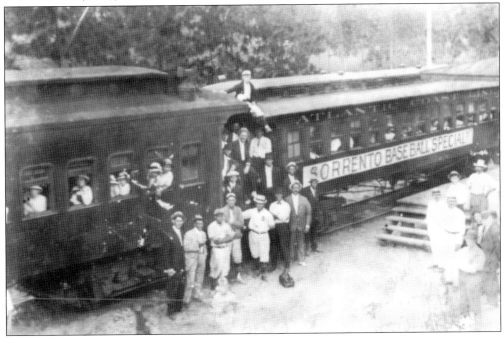

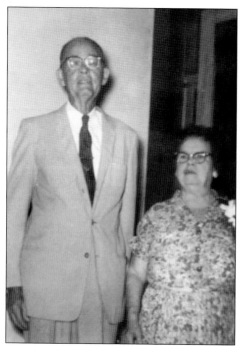

Pictured in the late-1950s photograph at left are Oscar Clarence Torbert and his wife, Floie Sanders Torbert. Oscar, born in 1887, was the stone mason responsible for all the rock and masonry work on architect Sam Stoltz's Storybook houses in Mount Plymouth, including construction of the massive chimneys and fireplaces. Floie, born in 1896, was the daughter of James Sanders, who owned Sanders Dairy. She became the Sorrento postmistress in 1929 and served the postal department for over 30 years, retiring in 1959. Floie made the post office a favorite gathering place for the community, and people came to admire the beautiful flowers she planted around the post office. The Torbert house, pictured in 1905, is still standing on State Road 46. Floie passed away in 1960 and Oscar in 1984.

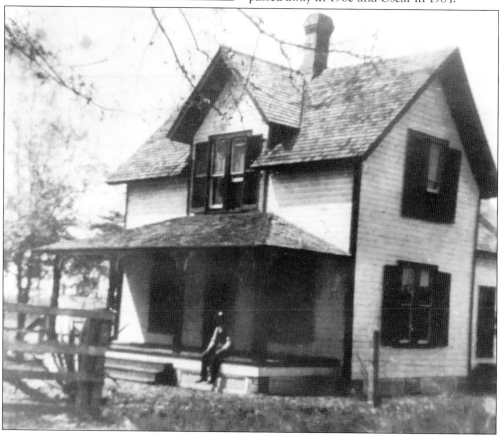

James William Sanders (pictured) and his wife, Anna Elizabeth Murray, operated a dairy farm located along today's Wolf Branch Road at the intersection of Orange Street. They had four children, two sons and two daughters—Oscar Daniel, Floie Clara, Ruth Anna, and Roy William. James was born in 1856 and passed away in 1927. Anna was born in 1875 and passed away in 1938. They are buried in the Sorrento Cemetery.

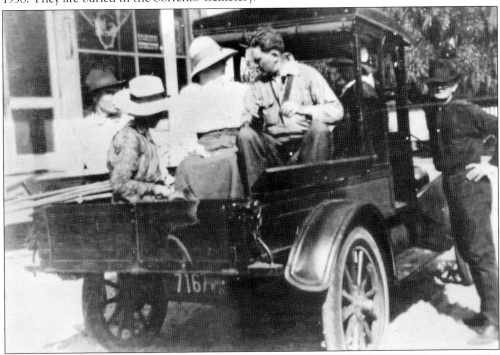

John Calhoun Bellamy was a merchant who owned a store next to the drugstore. He operated the shop until he passed in 1917. His son Walter Henry, standing next to the delivery truck in this 1921 photograph, continued the business. John was married to Arimenta E. Gore. He served in the 10th South Carolina Volunteer Infantry, Company B. (Courtesy of Lake County Historical Society.)

Hattie May Allen was born in Ohio and arrived in 1881 with her parents, Arthur and Hannah, when she was three years old. She was a postmistress, who resided in Sorrento for 76 years. Hattie, a popular town historian, was a member of the Presbyterian Aid Society, the Mayflower Society, and the Ocklawaha Chapter of the Daughters of the American Revolution. Hattie passed away in 1958.

Pictured in this 1925 photograph are, from left to right, Arthur Eugene Allen, granddaughter Margaret Aleen, daughter Hazel Allen Cowart, and granddaughter Doris. On March 4, 1921, Hazel married Manassas Foye Cowart, a World War I veteran who served in the 326th Infantry, 82nd Division. Manassas passed away in 1947 at age 55, and Hazel passed away in 1970. They are buried in Pine Forest Cemetery in Mount Dora.

Pictured in 1890, the Phillip Isaacs family is, from left to right, Phillip, Jennie, and son Herbert Leslie. Phillip Isaacs came to Sorrento in the late 1880s. In 1886, he was the editor of the *Highland Press*. He also owned orange groves in Sorrento. In the early 1900s, Isaacs was the editor of the *Fort Myers Press*. His son was born on October 22, 1886, in Sorrento.

In the early 1890s, Robert Pierce opened Sunset Hill Nursery. The nursery had 80,000 trees on 10 acres plus four acres of peach trees. In 1892, the Sunset Hill Post Office opened, but the great freeze of 1894–1895 ruined his business. In 1895, while at the train station, he had a heart attack and died at the Sorrento Hotel. The Pierce home (pictured) was the largest house in the area.

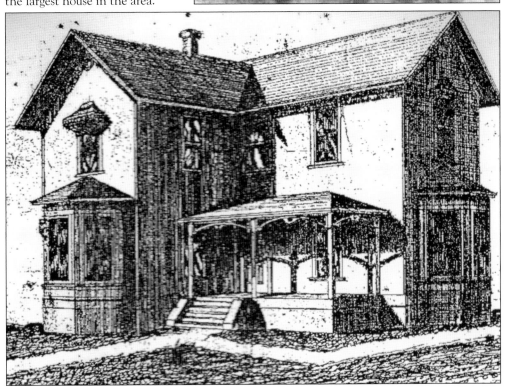

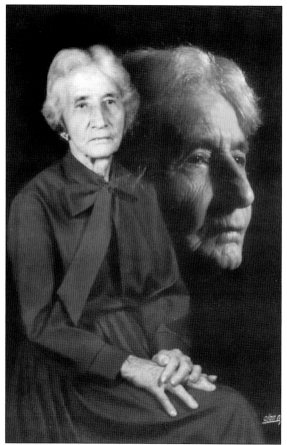

Maude Elizabeth Hughes Ferris (left) was born in 1891. She was married to John Ferris of Tennessee. John was a trapper, hunter, and farmer prior to moving to Sorrento. His move was prompted by Maude's brother Lawson Hughes, who had previously moved to the area. After John found work in the orange groves and as a fruit packer, he sent for Maude and their three children. Maude passed away on October 13, 1990, and is buried in the Sorrento Cemetery. On St. Patrick's Day 1926, Maude was fixing lunch and preparing to bake biscuits when, following a torrential rain, a tornado hit (below). Maude recalled, "I fell down on the floor and I just watched everything go around above me." The force of the winds drove a nail into her temple, but fortunately, the wound was not serious, though it left a permanent scar.

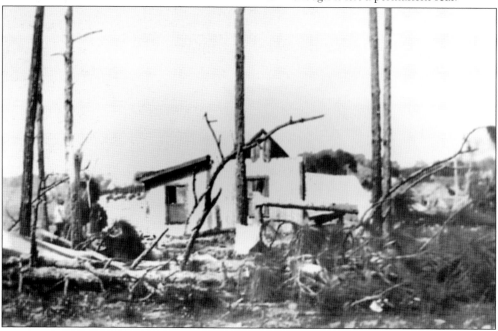

Travis and Freddie Battle Woodham (right) were married in December 1936 in the Sanford Courthouse. The couple lived in Sorrento for the remainder of their lives and raised four children—Linda Ray, Edwin, Mary Jewel, and Jean. Most of their work life was in the citrus industry. Freddie Battle's father, Thomas Addison Battle, was co-owner of the Battle Lumber Company (below) with his brothers George and Frank. Another brother, Rabin, kept the books. At its peak, the mill employed over 350 people. They brought the first Delco Plant to town and furnished electricity for the streetlights. The Battles built homes in the area for their employees and families as well as a boardinghouse and stores, and they also supplied lumber for the First Baptist Church.

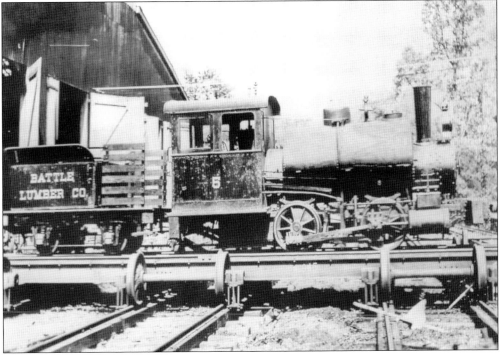

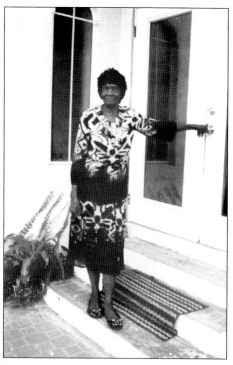

Mother Bertha Mae Banner Perry was born in 1937 in Georgia. She relocated to Florida in the mid-1950s, where she met her husband, George Perry. The couple had five children. Bertha was a member of the Refuge Church of Our Lord Jesus Christ for over 60 years. She was an entrepreneur, realtor, community leader, missionary, and businesswoman who operated the popular Bertha's Produce on State Road 46. Bertha passed away in 2018.

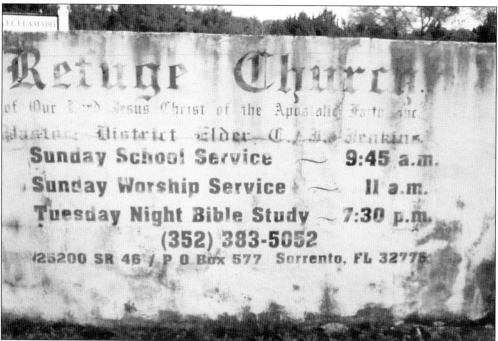

The Refuge Church of Our Lord Jesus Christ began in Sorrento in 1936 when Deacon Eli and Mother Lottie Thomas began evangelizing the logging community. The church initially met in a "hush harbor"—a secret place to practice religious traditions. The Thomases donated land for a church, and in 1945, a brick building was constructed by the first pastor, Elder Samuel Green. Congregant Lena Pearl Jackson was a member since the church's founding.

The Harvey family is, from left to right, Minnie Bell Williams Harvey (mother), Leslie Ray Harvey, Beverly A. Harvey, Beaufort M. Harvey, Zethel Loerine Harvey Williams, Thomas M. Harvey, Minnie Lee Bollar, Robert C. Harvey, and Robert Lee Harvey (father). In 1953, Minnie and Robert moved to Sorrento from Georgia. Their first home was on Strawberry Avenue, and they worked in the fields at Zellwood Farms, where they harvested vegetables.

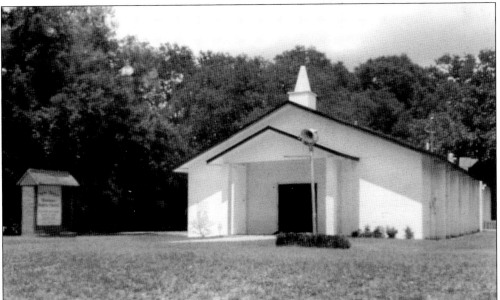

New Hope Missionary Baptist Church began as a Sunday school in the mid-1950s at the home of Johnny and Katie Stiggens. The founding pastor was Rev. Early W. Wade, who, along with his wife, Susie, happened to drive through town one Sunday. Thurman and Annie Collins donated land for a church on the west side of County Road 437. The new church (pictured) is located across from the original site.

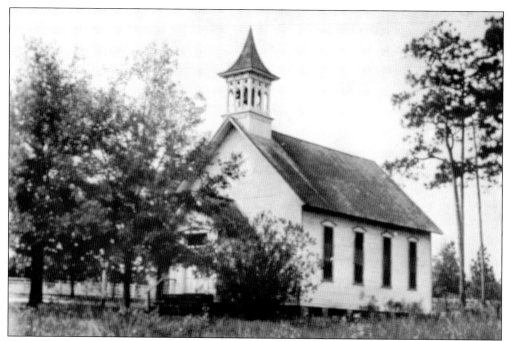

Laura Emerson Gradick's poem "The Church Among the Pines" is an ode to the Sorrento Presbyterian Church. The church, organized on May 11, 1884, is the first and oldest church in Sorrento. The first services in the building were held in the fall of 1886 with Rev. Charles Montgomery Livingston. The last service for the church was held on Sunday, July 19, 2009.

The Livingston family is, from left to right, Grace Livingston Hill, Grace's daughter Margaret, Marcia Macdonald Livingston, and Rev. Charles Montgomery Livingston. The reverend pastored at the Sorrento Presbyterian Church as well as the Seneca Presbyterian Church. Grace became a well-known novelist who wrote over 100 books and stories. She had a second daughter named Ruth, who posthumously completed her mother's final book, which was published in 1948.

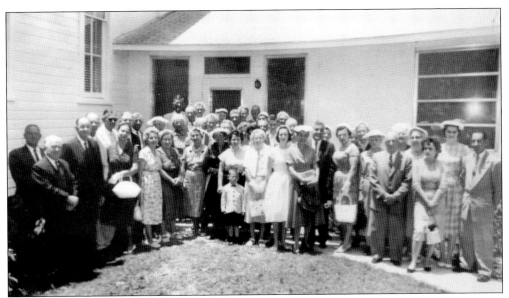

Groundbreaking for Sorrento Presbyterian Church's fellowship hall began in 1959. It was opened and dedicated in 1960. In 1971, it was rededicated as the Glen Schillerstrom Fellowship Hall in memory of the pastor serving during construction. This photograph was taken at the dedication ceremony. Among the congregants were Bill Garland (second from left) and Adelbert Lent (fourth from left). Frances Geddes is standing behind her son David (front center).

The Sorrento Presbyterian Church manse, built in 1920, is located on Summit Street. In 2017, Kim and Morris Frye received the Historical Home Award from the East Lake Historical Society for the preservation of the former manse. Past owners of the house include the Weinmann and Carter families. The house is still standing.

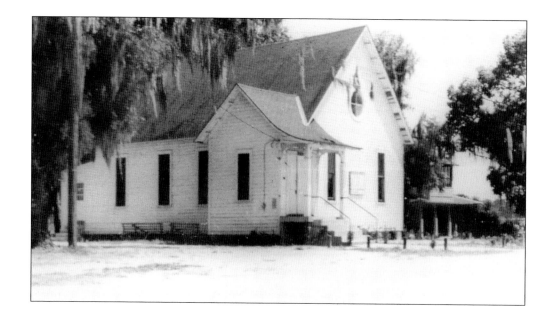

On October 12, 1912, a group of 22 people wishing to organize a Baptist church met in the schoolhouse. Services were held at the school until January 1913. George Battle donated property to build a church (above). This church was used until 1956, during which time Rev. Cecil Baughman was the minister. The church purchased over three acres on Sorrento Road for a new church building (below). In 1961, a fellowship hall was constructed, and services were held there until the auditorium was completed in 1965. In the 1980s and 1990s, further remodeling took place with the addition of a new baptistry, classrooms, and kitchen.

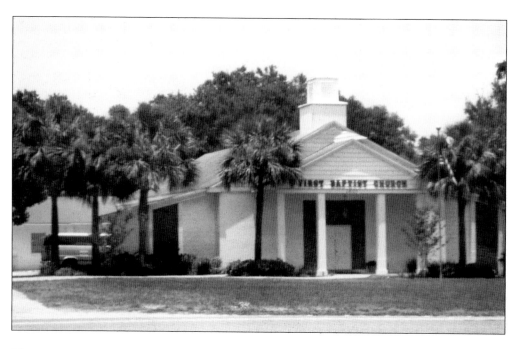

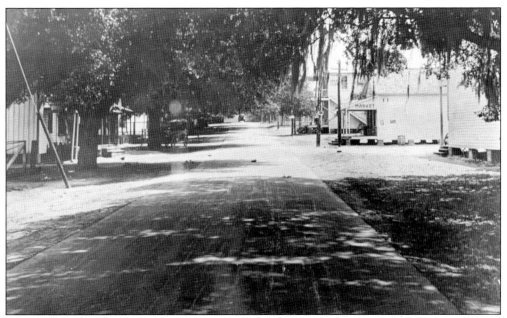

The photograph above was taken on May 2, 1917. From 1915 through 1916, a 15-foot-wide sand asphalt pavement was laid from Sanford to Sorrento—about 2.5 miles from Mount Dora. Horse prints and wheel ruts can be seen in the photograph. They were caused by not allowing the pavement to fully cure before traveling on it. The Continental Works Company, which was founded in 1871 and still operates today, was commissioned to lay the pavement. In the 1954 photograph below, Jim W. Geddes walks along Sorrento Avenue to Burns gas station on the right side of the road to use the telephone. The Driggers store is on the left side. Geddes lived on Vine Street with his wife, Doris. He served in the US Navy during World War II and is interred in the Sorrento Cemetery.

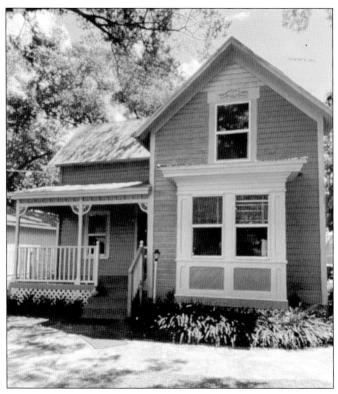

The Ham House on Summit Street has sheltered many families. In 1884, H.O. and Lucretia Williamson owned the house and soon sold it to John William and Martha Sommerville. In 1889, Francis and Lizzie Ham purchased the property, and the home received the Ham House moniker. From 1906, when Walter and Mary Cooper purchased the house, through 2022, when Charles and Beverly Bradford lived there, 15 families occupied the home.

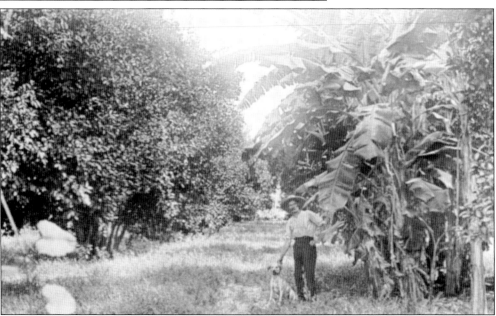

John William Sommerville and his dog inspect his citrus and banana grove on Summit Street. In addition to being a planter, Sommerville was a logger who operated a sawmill on Wolf Branch Road. He and his wife, Harriet, came to Sorrento in 1882. In 1895, the Sommervilles, along with their two daughters, Flora and Harnet "Hattie," traveled to Atlanta, Georgia, to search for a new home. They soon relocated there.

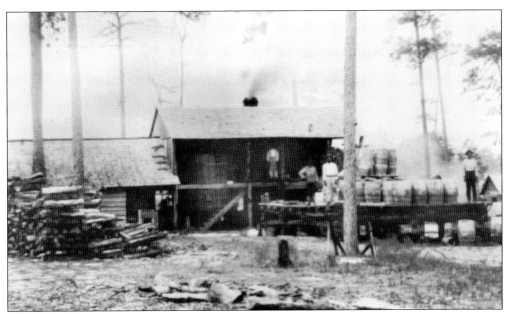

There were numerous naval stores in the Sorrento area in the early 1900s. The J. Williams and Company Naval Store (above) was one of the largest in the state. It was located behind the old Baptist church and was managed by W.D. Smith. The Williams and Company turpentine still and naval store was relocated from Messina, which is now a ghost town a few miles northeast of Sorrento. Naval stores such as tar, turpentine, pine oil, and rosin were obtained from the pine trees and were widely used in maintaining the seaworthiness of wooden sailing ships. Florida was the nation's leader in naval stores production from 1905 to 1923, though in Sorrento, the turpentine industry ended abruptly by 1912. It was replaced by the lumber industry. A village of laborers' cabins in the pine forests of East Lake County is pictured below.

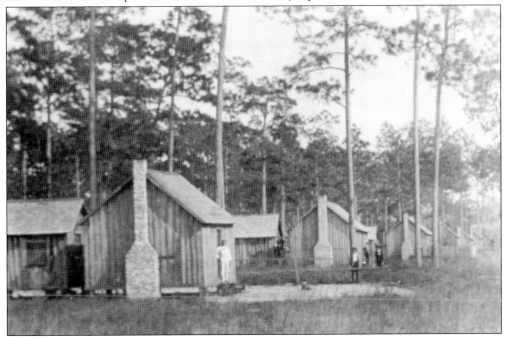

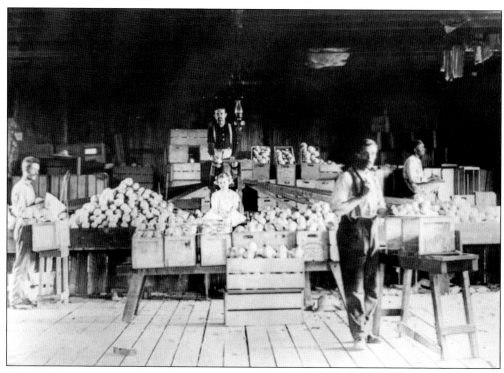

J.E. Parker owned orange groves and operated a packinghouse. The little girl in the photograph is Berti Roberson, and the gentleman, second from the right, is Dixie Royal Sr. The packinghouse was torn down and the lumber used to build a garage. Later, the Umatilla Packing House, located near the railroad tracks, was built and operated in town until 1929, when it burned.

The McDonald store on Sorrento Avenue was built by the Battle Lumber Company and served as an ice cream parlor and a beer and wine garden prior to its purchase around 1900 by Mollie Knight, an aunt to Sybil McDonald. In 1950, Sybil and Paul McDonald acquired the property and moved the store farther back from the road. When Paul passed away in 1971, it was sold to the Driggers family.

Sorrento Bait and Tackle opened in January 1986 on State Road 46. The shop, which was owned by Capt. Joe and Garie Hussey, offered live bait, tackle, fishing and hunting licenses, and taxidermy services. Captain Joe, a veteran fisherman and expert guide on Central Florida's lakes and waterways, also operated the Harris Chain of Lakes Fishing Guide Service.

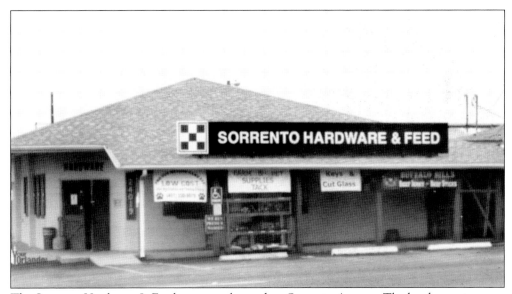

The Sorrento Hardware & Feed store was located on Sorrento Avenue. The hardware store was part of a group of buildings owned by Johnny Treadwell, who had owned this property for 20 years. Allen Call purchased the store, calling it Village Hardware & Feed. The old Sorrento post office (not pictured), located to the right of this store, was the original section of the hardware store.

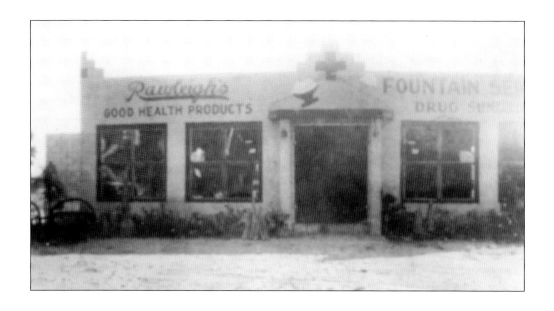

In the 1940s, Paul Pochettino built the Fountain Service Station (above) on Sorrento Avenue. They sold cold drinks and Rawleigh's Good Health Products. There was a telephone booth outside and one gas pump. Pochettino and his wife, Lena, lived across the street in the two-story house where the Bennett family had once lived. Some years later, Pochettino traded the house for a Packard car. Harold "Pop" and Elenor Sammons moved to Sorrento from Pennsylvania in 1950. They bought the Fountain building and opened the Palms Café. Now, for more than two decades, the biker-friendly Oasis Saloon (below), which features live rock music, has occupied the building. The Oasis refurbished the old establishment with its recognizable cactus and palm oasis mural painted on the popular tavern's exterior.

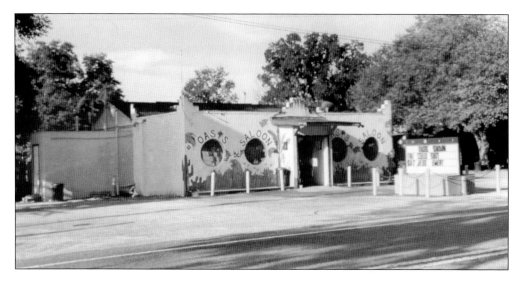

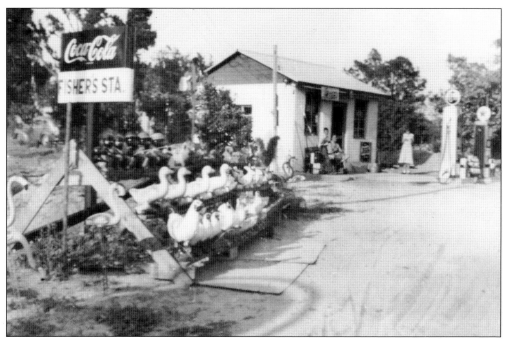

Ernest and Ida Fisher, with their children Buddy, Mary Alice, and Jimmy, moved from Alabama and settled in Sorrento in February 1951. They rented this gas station (above) at the northwest corner of State Road 46 and Summit Street for a year. In 1983, Pat Mooney visited Sorrento and stopped at the old Fisher Station—now owned by Al Haughn. Mooney visited Sorrento over the next five years. In 1988, Haughn said he could not handle the work anymore and that he needed cataract surgery. Mooney purchased the station and opened Pat's Import Auto Repair (below). He specializes in the sales of quality pre-owned vehicles.

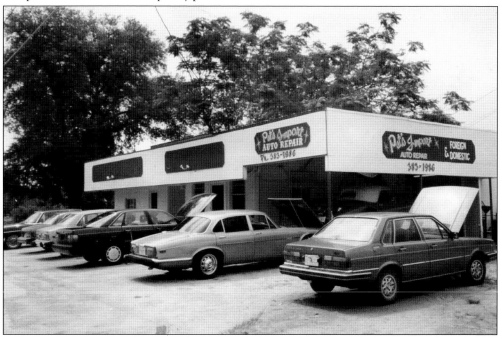

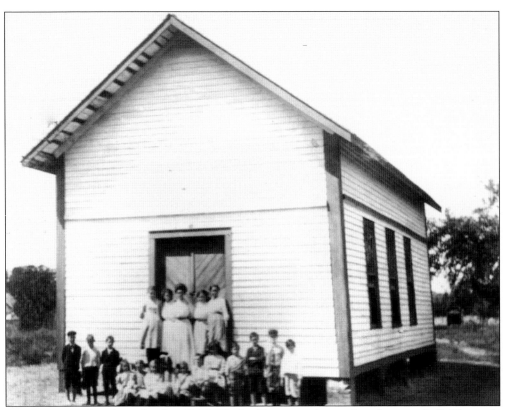

Sorrento opened its first school in 1886. The building was also used as the town hall. The early teachers were Prof. A.K. Beam from Ohio; Ada Brooks from Ohio; Mrs. Henry Reeve, a former teacher from Brooklyn, New York; Professor Dodson from Iowa; and a Mrs. Thomas, a teacher of languages from Wooster College, Ohio. The Sorrento Literary Society hosted monthly programs, various church denominations held services, and the community Sunday school (above) conducted classes at the hall. A second school, which also served as the town hall, was constructed in 1912 on land donated by H.B. Paxton. This school served until 1936. Below is a class photograph for the black school from January 1910. That school was established in 1882.

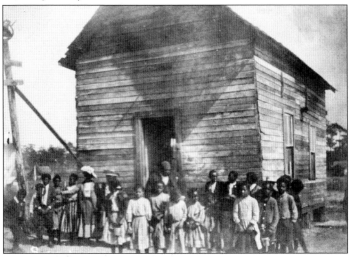

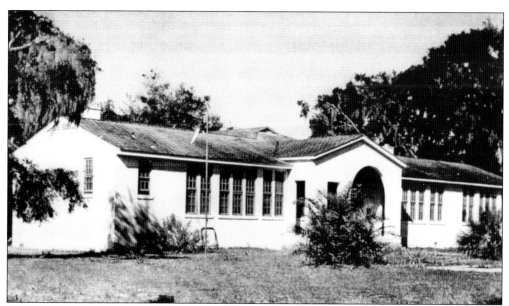

Sorrento lost two schoolhouses to fire in 1936. One was the old 1912 schoolhouse, and the other a newly constructed Works Progress Administration (WPA) building. The citizens quickly erected the school pictured above and had it ready for occupancy for the new school year in September 1937. The school closed in the late 1950s. Below, on Monday, August 9, 1993, the wood-frame, three-room, 5,000-square-foot Sorrento School erupted into flames that rose as high as 50 feet. Two companies of firefighters battled the blaze deep into the night. Two of the firefighters, Murray Adkins and David Hooten, suffered heat exhaustion and were taken to Waterman Hospital. Sorrento residents, some of whom had attended the cherished school in their youth, watched the school burn.

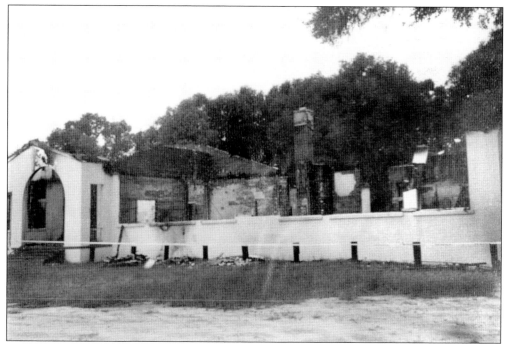

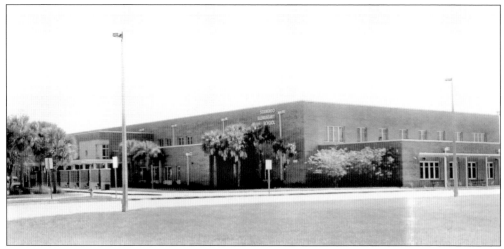

On May 17, 2010, the Lake County School Board held a workshop. Members of the East Lake Historical Society were in attendance. School superintendent Dr. Susan Moxely informed the board that it needed to give Elementary School J a permanent name. A motion was made to name the new school Sorrento Elementary School. The school board's vote was unanimous, declaring it a historical moment for Sorrento.

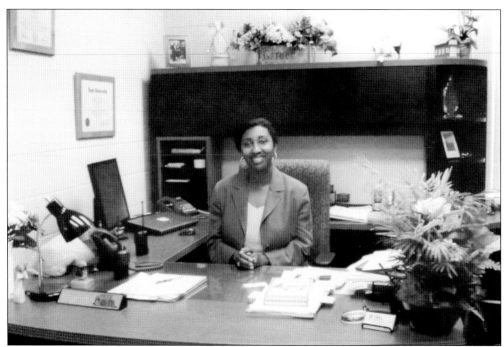

Mollie Cunningham, who is proud to tell the story of her grandmother's dream for her to become a schoolteacher, became the first principal of the new Sorrento Elementary School. In 2020, Cunningham was the first African American to be elected to the Lake County School Board. Prior to her election, she had worked for Lake County schools for over 35 years, which included serving as principal of four schools.

The Driggers family is, from left to right, (first row) Mollie, Marcia, and Furmon; (second row) John and Cathy. In 1942, George Raulerson constructed a building for Ida Battle on Sorrento Avenue. In 1945, she sold it to L.B. and Neppie Driggers, who operated a grocery store. In 1950, Furmon and Mollie bought the business and operated Driggers Store until their passing—just days apart in 1970.

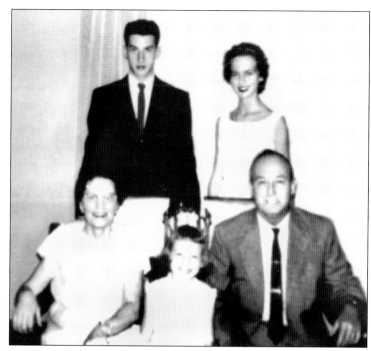

Pictured with Carlton Porter Henkle in 2011 are, from left to right, his granddaughter Darlene Mallory and his twin sisters Jean Henkle Marshall and Joan Henkle Grey-Sweet. Carlton's grandparents Eugene Carlton and Catherine Cookingham Porter from New York spent the winter months on a 17-acre plantation on Franklin Avenue, where in 1909 they built a precut Sears house. In 1959, grandson Carlton and his wife, Dorothy, moved into the home.

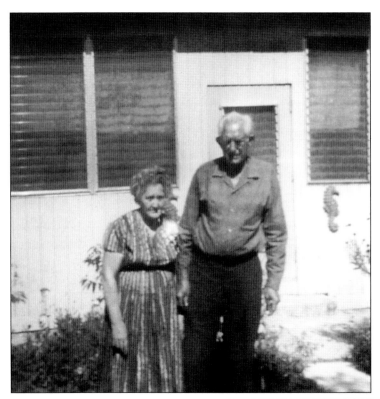

Ollie and William McKinley Carter moved to Sorrento from Kingsport, Tennessee, in January 1958. They lived at the old Sorrento Presbyterian Church's manse on Summit Street. The Carters had 10 sons and 4 daughters. William was a carpenter whose sons and grandsons followed in his footsteps. The old First Baptist Church as well as the new church bore the Carter trademark. They constructed many homes and buildings throughout Central Florida.

Pictured are sisters Margaret Aleen Cowart (left) and Doris Cowart McKinna (right). Doris was married to Navy veteran Joyce Fleet McKinna. She had co-owned a barbeque restaurant and catering business with Joan Asmus. Doris was an elder at the Sorrento Presbyterian Church and was active in many organizations, including the Order of the Eastern Star, the American Legion, and the United States Daughters of 1812. The 66-year-old Sorento native passed away in 1990.

Russell Sage Chaudoin Sr. (1891–1970) and Gertie Edna Chaudoin (1899–1998) originally lived in Bay Ridge. Their eldest daughter Pearl was born there. The Chaudoins moved to Franklin Avenue in Sorrento. Russell, a carpenter by trade, and Gertie raised nine children. In addition to Pearl, there were Russell "Junior," Dewey, Shirley, Margie, Edna Mae, Edgar, Rube, and Allie.

This photograph of Edwin and Sara Wade was taken at the grand opening of the First National Bank branch office in Sorrento on August 24, 1985. Edwin was an upholsterer and president of the Civic Association and, along with his wife, was heavily involved in community activities. Edwin, a World War II Army veteran, passed away in 1990. He is interred at the Sorrento Cemetery.

JR's Automotive Works is owned by Richard Jimenez, who moved to the area in 1994. He purchased the old fire station on County Road 437 in 2002 and opened his shop. Jimenez has been in the automobile business since the 1970s, specializing in the repair of all makes and models. He has two sons, Richard Jr. and Jason, whose initials, along with his, are used for the company's name, JR's.

Merv's Mower is located at the intersection of Sorrento Avenue and County Road 437 South. The business was originally owned by Merv Terry, who opened the repair shop in 1987. In 1998, Billy Cates, a 10-year employee of Terry, purchased the business and retained the name Merv's Mower. Merv's services all makes and models of lawn equipment and is a Snapper mower dealership.

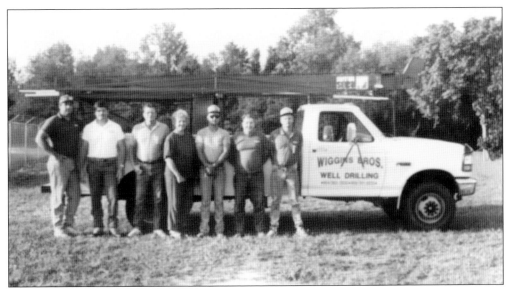

Wiggins Brothers Well Drilling was established in Zellwood in 1939 by Jim and Woodrow Wiggins. In 1969, after the brothers retired, Woodrow's son Sam took over the business and moved it to Lake County. Four generations of Wiggins have worked in the family business. Pictured are, from left to right, Kevin Wiggins; Greg Wiggins; Everett "Sam" Wiggins; Sam's wife, Ruth; Lonnie Van Zant; Ed Field; and an unidentified employee.

Robin's Restaurant was located on State Road 46 in the East Lake Plaza. It was very popular in the 1980s and 1990s and was known as the unofficial meeting place for the local ranchers and nurserymen. Pat Pumphrey owned the restaurant, and her son Ron Cole, wearing the vest and name tag in the photograph, was the manager. Old-timers enjoyed familiar faces, community gossip, and "Home Cooking at its Best!"

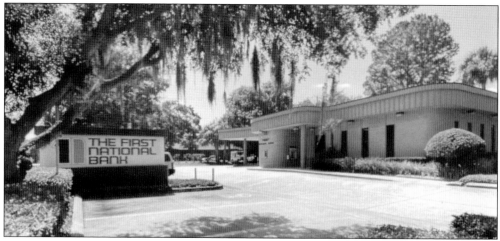

The First National Bank was established in Mount Dora in 1925. It was originally located in a small building on Donnelly Street, just south of Fifth Avenue. In 1926, a brick structure, commonly remembered as the "old bank building" was constructed on the corner of Fifth Avenue and Donnelly Street. Throughout the Depression, the bank's doors remained open. The First National Bank opened this Sorrento branch (above) on State Road 46 in the summer of 1985. Johnny Treadwell was the first person to open an account. Below are the first staff of the bank. From left to right are (first row) Bonnie Collins, Shirley Grantham, and Kathie Bartling; (second row) Gloria Scogin, Judy Willard, Laura Sanders, and Penny Hicks. Shirley Grantham was the vice president and branch manager for 10 years and, along with other branches where she worked, had a 37-year career. She retired in August 2022.

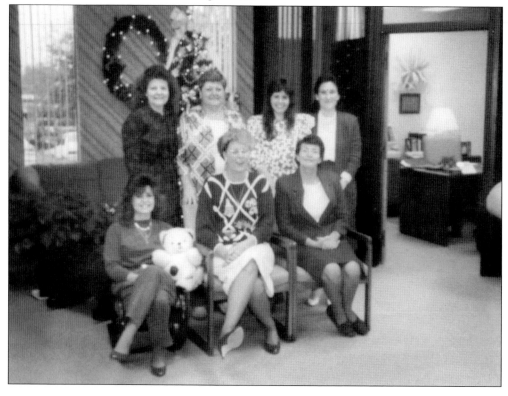

The original post office was located on the north side of Sorrento Avenue by the train depot. The red-painted post office burned down in January 1930. The Cowart store served temporarily until mid-year 1930, when a small white building was constructed. Floie Torbert was postmistress until 1959, and then Richard Weinmann was appointed by President Eisenhower. Weinmann served until 1975, which included seven years in the post office pictured here.

The East Lake County Chamber of Commerce constructed this structure in 1987–1988 to be used as a community building. This venue became a hotspot for many activities and fundraisers. On October 6, 2000, Lake County rented the building and dedicated it as the East Lake County Library. The library closed on July 9, 2022, with a new library to open at East Lake Sports and Community Park on Wallick Road.

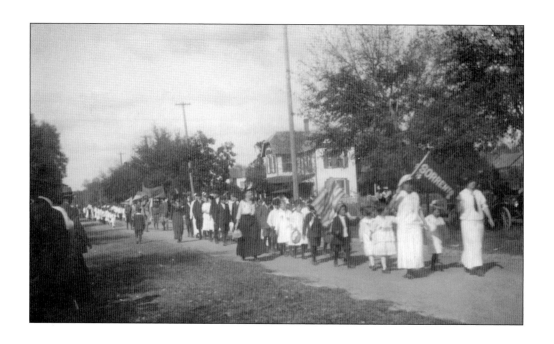

From 1913 through 1919, the Lake County school fair was held in Tavares. Prior to World War I, school fairs were an annual event and featured exhibits and activities that encouraged the schoolchildren to take special interest in their work. The school fairs were discontinued in Lake County due to the activities of the Great War with the hope of reviving the fairs after the war. The 1917 school fair was considered the best-staged event. Thirty-seven of the 40 county schools were represented, with over 1,200 students marching in a parade at the closing ceremony. Above, Sorrento students, teachers, and parents march along Sorrento Avenue in 1914. Below, the students and teachers take their position in the parade line in Tavares in 1914.

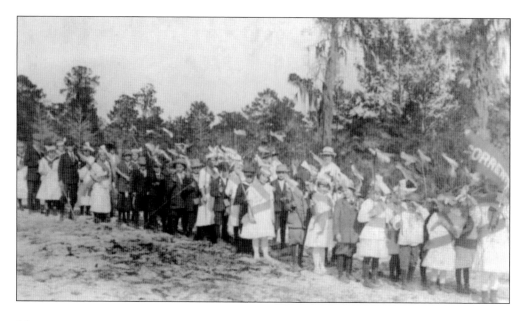

In 1986, the East Lake Chamber of Commerce purchased the old Kennedy house on County Road 437. In 1987, the chamber held its first annual fall festival, pictured here. One of Sorrento's largest gatherings, the event began with a parade through Sorrento, with entertainment by the Holly East Cloggers and Blackwater Bluegrass Band, and activities such as catch the greasy pig, a pie-eating contest, a dog show, and arts and crafts.

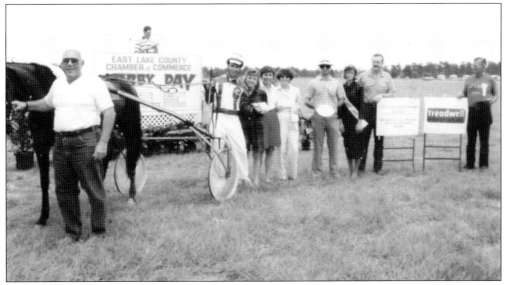

In the 1980s, the Simpson family came to Sorrento to build a training center for their Standardbred horses. They purchased property and opened Simpson Training Center on County Road 46A. Through the Simpson's generosity, the East Lake Chamber of Commerce hosted an annual Derby Day for several years. Alan Call (second from right) of Village Hardware & Feed and Johnny Treadwell (far right) of Treadwell Enterprises were sponsors.

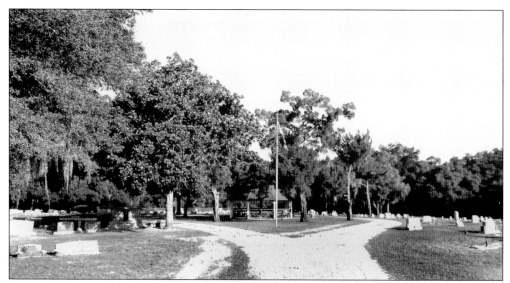

Sorrento Cemetery was established in 1890 on land donated by Calvin Butts. The cemetery consists of 4.5 acres of land and is located on Oak Lane. The Sorrento Cemetery Association Inc. was established to provide burial spaces and organize maintenance and improvements. When entering the historic grounds, a gazebo, built in 1897, is the focal point, with the American flag flying proudly in the foreground. The first Memorial Day service here was held on May 27, 2002, presented by Sorrento Cemetery Association and Mount Plymouth VFW Post 10474. Below, the first board of trustees for the Sorrento Cemetery Association are, from left to right, Ray Lewis, Johnny Treadwell, Lester Weinmann, A.V. Lent, Johnnie Boyd, Edwin Wade, and James J. Jones. Not pictured is board member Frank McClenney, who took this early-1990s photograph.

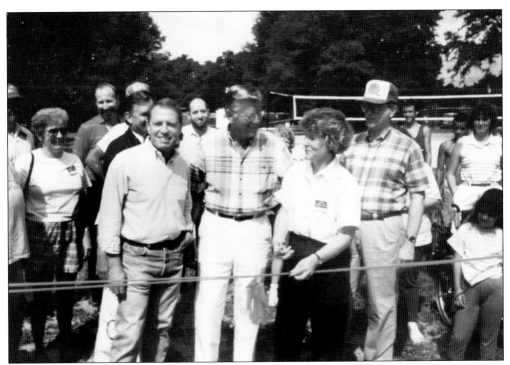

Sorrento Park, located on Church Street, was built in the 1980s. It was created with a community development block grant, spearheaded by Lake County commissioner Tom Windram. In 2006, significant improvements were made to this park under the direction of Bobby Bonilla of the Office of Parks and Trails. Catherine Hanson (pictured) had the honor of cutting the ribbon.

J.A. Croson Plumbing/HVAC contractors was founded in 1959 in Columbus, Ohio, by Jim Croson (pictured) with $500 borrowed from his mother and a 1950 pickup truck that Croson is sitting in. The company established a Florida division in 1979. Since the company's inception, it is recognized as one of the premiere mechanical contractors in the Southeast, involved in thousands of residential, commercial, and hospitality projects. (Courtesy of J.A. Croson.)

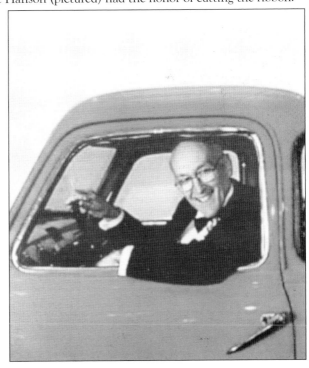

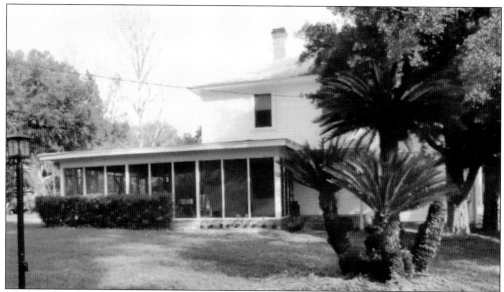

Pictured is the home of Newton Emmert and Alice Ruth (Kitchin) Strite. Newton was a citrus farmer and Alice a teacher at Mount Dora Public School. The house was located off Plymouth Sorrento Road, near the Lake County and Orange County border. It was razed for new road construction. The Strites' daughter Clara Ruth and her husband, Tommy Holder, also lived there. Alice was born in 1906 and passed away in 1999.

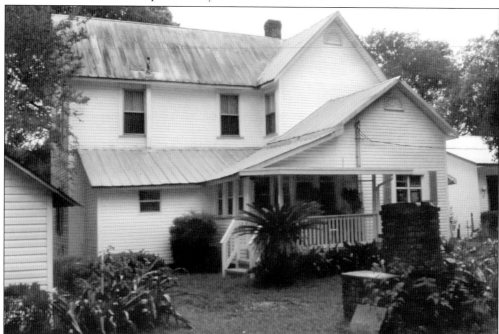

The home of Luther and Macie Bennett was built by Dixie Royal Sr. around 1919. Macie was born on May 4, 1940, in Tennessee to Pearson and Rose Stephens. She married Luther on January 11, 1955. Soon thereafter, they moved to Sorrento, where they raised three children—Sara Jo, Ricky Dan, and John. Macie, a seamstress, has a collection of over 75 sewing machines—all in working order.

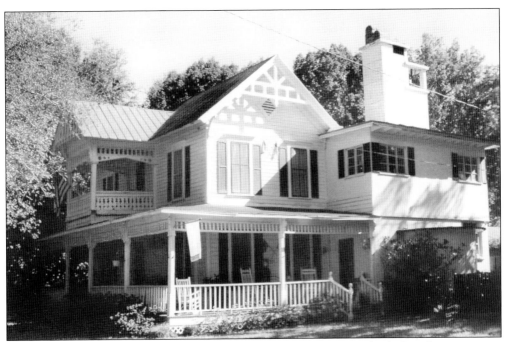

Dr. Neal Roberson of Tennessee came to the area in the late 1880s. He built this white, two-story house that was used as his hospital and office. The house became known as the "Funny Farm." House calls were made by horse and buggy. When his buggy needed repairs, he took it to the Carriage House on Lawrence Street, now known as the Old Buxton House.

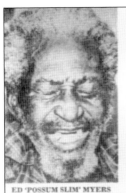

'Possum Slim' would hate to end his days in jail

APOPKA, Fla. (AP) — Ed "Possum Slim" Myers, a 105-year-old self-described "wild rabbit," says he's not worried about a possible life sentence in the shooting of two of his friends.

"Life? I reckon I've had it," Myers said. "I'd rather be up there — heaven — than down here. But I'd hate to end my time on this Earth in prison."

Myers was released from Lake County Jail on Saturday in the custody of a friend. He is charged with second-degree murder in the shooting death June 7 of Louise Stewart, 52, and the wounding of her companion, Sammy Tolbert, 44.

Myers told newsmen he was justified in shooting Mrs. Stewart and Tolbert in the neighboring community of Sorrento because "they kept at me. They took all my money. I couldn't stand it no more."

Under terms of his release, Myers must remain in Apopka with his friend, Oscar Robinson.

"One time I made me some moonshine and they caught me. But that was

—adv.—

Summer Hours Burger King
4th St, Leb St, Union Blvd, MacArthur Rd
Sun-Thurs 10-12 Fri & Sat 10-1

Vacation Bible School Supplies
Hackman's Bible Book Store

a long time ago."

Myers, who said he was born "in the flats of Virginia, by the James River," says his mother, father and sister were slaves "but I was born free."

He says he's lived in Lake County 53 years, and has spent his time "mostly picking fruit."

Myers says, "I never married. I've got sons and daughters, though. I was a wild man, like a wild rabbit. Reckon I'm a dead rabbit now.

"My mother didn't know what days were," Myers says in recalling his early life. "She just knew daylight and dark. But she told me about Jesus, and he's been with me all the way. Even now."

ED 'POSSUM SLIM' MYERS
. . . a 'wild rabbit'

Ed "Possum Slim" Myers was the son of former slaves and worked as a picker and laborer. In 1975, at the age of 108, he made national news when he killed his girlfriend, who was planning to steal his social security checks. He confessed and was ordered to stay out of Lake County for a 15-year probation period. He died of natural causes in 1980 at the age of 113.

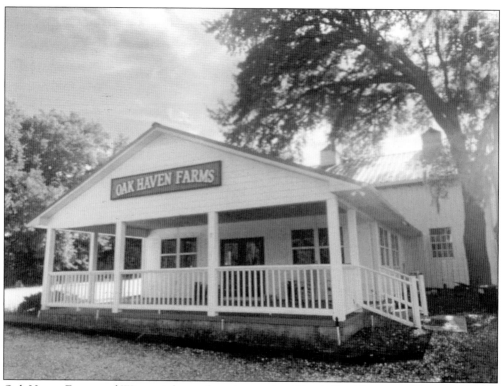

Oak Haven Farms and Winery is located on the gentle rolling hills of Sorrento. Karen and Harry Stauderman and daughter Lynn began the 20-acre strawberry farm in 1996. Their iconic oak tree is positioned in the heart of the farm, which serves as a landmark and is celebrated on their wine logo. Oak Haven Farms and Winery is listed in the Mount Plymouth Historic Registry. (Author's collection.)

In 1987, Judy and Jack Ewing planted their first Christmas trees, and in 1989, they opened Santa's Farm and Christmas Tree Forest on Huff Road. Visitors start with a hayride through the forest to pick out a tree, which is then cut down by the guest. There is a gift shop and petting zoo as well as the Reindeer Haystack, Santa's Flight Zip Line, and the Crazy Elf Christmas Maze. (Author's collection.)

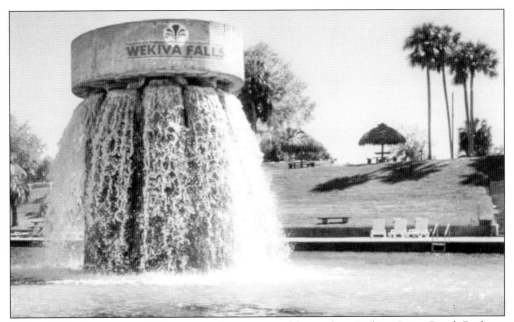

Wekiva Falls is a premiere RV resort and campground located on Wekiva River Road. Built on over 100 acres in the East Lake County wilderness, the resort has a natural sulphur spring that cuts a path through the center of the park. Guests can float all the way to the Wekiva River. The spring, trails, picturesque landscape, and natural wildlife gives the feel of an old-time Florida attraction. (Courtesy of Wekiva Falls.)

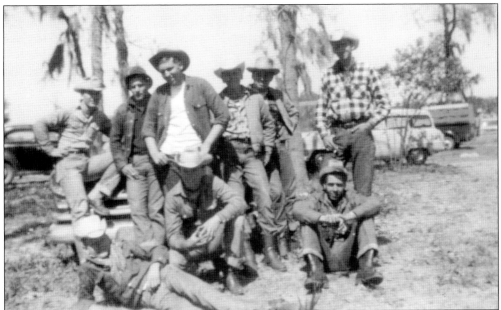

The Rough Riders participated in the Fourth of July and Labor Day rodeos at Griffin's Ranch on State Road 44. The men owned their own horses. Competitions included bull riding, barrel races, bucking horses, pole bending, and wild cow milking. The Griffin family hired Buddy Fisher (sitting far right) to help run the riding stable, but after a few days of work, Fisher was drafted to serve in the US Army.

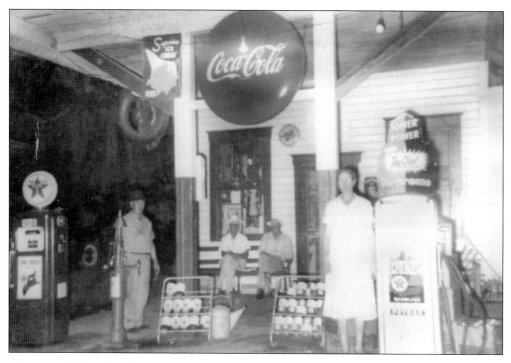

Ernest and Ida Fisher (standing) purchased this gas station in 1953. They sold Texaco and Colonial gas for 29¢ a gallon. Soda pop was 6¢ a bottle, and bologna sold at 10¢ a pound. Every day at noon, Ernest turned the switch that blew the 12:00 whistle that was located a block from the station on County Road 437. There was a bench outside the store where someone was always sitting. When Ernest was not busy, he had a checkerboard waiting to play someone. The board was homemade, and bottle caps were used for checkers. The Fishers retired in the 1960s. Al Lambert (left) and Johnnie Boyd (right) are sitting on the bench. Below at the Fisher station in 1958 are, from left to right, Cathy Driggers, Marsha Driggers, Mary Jewel Woodham, Janice Thompson, and Jean Woodham.

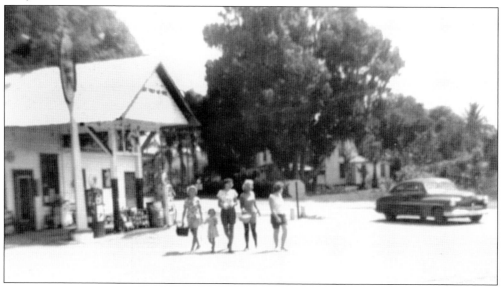

Maggie Kirby and Buddy Fisher were married at 4:00 p.m. on June 7, 1959, in DeLand, Florida, after a 10-month courtship. After they married, they went to The Palms for dinner, but the restaurant was closed. So the couple went to Buddy's parents' store to pick up a loaf of bread and sliced baloney and that was their wedding night dinner. Buddy rented a garage apartment, where the Sorrento Post Office is located now, from Johnnie and Pearl Boyd for $40 a month. Three months later, the Fishers bought their first home on State Road 46, where all their children were born and raised. The children, pictured below in 1976 with Maggie and Buddy, are, from left to right, Randy Eugene, Lonnie Ray, Rickey Lee, Debra Ann, and Joseph Allen. (Both, courtesy of Maggie Fisher.)

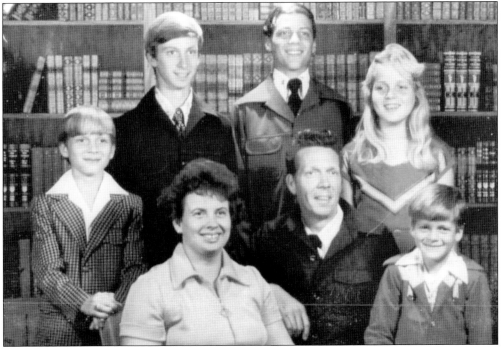

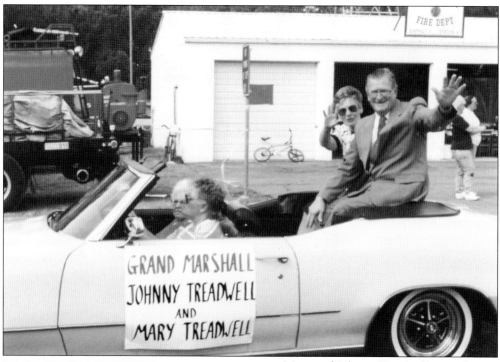

GRAND MARSHALL
JOHNNY TREADWELL
AND
MARY TREADWELL

Mary and Johnny Treadwell were the former owners of Treadwell Enterprises, which included the Sorrento Grocery Store, Sorrento Hardware & Feed, and Treadwell Greenhouse. Johnny was known for his kind and generous ways. He was the founder of the East Lake Chamber of Commerce. On July 1, 2010, the Johnny C. Treadwell Memorial Highway was designated along State Road 46 from Round Lake Road to County Road 437.

Lester and Geraldine "Geri" (Billette) Weinmann, pictured at the 2009 Lake County Historical Society awards banquet, were married in 1964. Lester had moved to Sorrento in 1943 and attended Sorrento School from 1944 to 1947. After he graduated from Mount Dora High School in 1957, he served in the Navy from 1957 to 1960. Lester was the first president of the East Lake Historical Society. The Weinmanns had two children—twins Sandra and Steven.

Ruby Grace (Holt) Smith and Alto Gaston Smith are pictured in 1952 with their children, William Gaston "Buddy" and Shirley Grace, whom Alto named for child actress Shirley Temple. In 1950, the Smith family moved onto the Bowen cattle ranch, where Dr. Bowen built them a home. Alto was the overseer of the ranch and groves. Buddy Smith served as Calhoun County sheriff for 24 years. (Courtesy of Shirley Meade.)

On September 3, 1955, Frank Meade of Mount Dora married Shirley Smith at the Bowen Ranch, where the Smith family lived. Frank was still in the Navy at this time, stationed on the USS *Tidewater* at Norfolk. When he returned home, the couple lived at Rock Springs before moving to Sorrento. Shirley was a teacher assistant at Roseborough Elementary for 21 years. Frank and Shirley have two children. (Courtesy of Shirley Meade.)

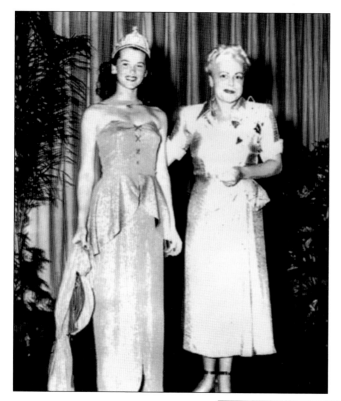

Lois Driver (left) is pictured with Ceila Claflin (right), president of the Ice House Players, in 1945. Claflin presided as an emcee of a local beauty pageant and presented Driver as Tangerine Queen. Driver, the daughter of John and Delphia Driver and sister to actress Nancy Walters, was born in 1929 at James Laughlin's Sydonie estate. She became a fashion model, an aquamaid at Cypress Gardens, and a magazine cover girl.

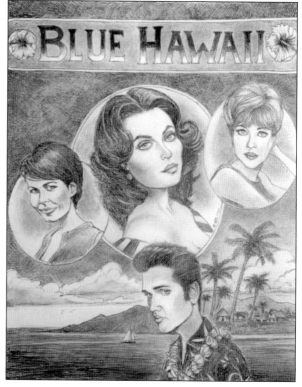

Nancy Driver (center) was born in the Mount Plymouth Hotel in 1933. In 1952, she began her career as a cover girl model. Billed as Nancy Walters, she appeared on many television shows, including *77 Sunset Strip*, *Get Smart*, and *Gunsmoke*. Her movie credits include a lead role in the Elvis Presley movie *Blue Hawaii* and as a nun alongside Debbie Reynolds in *The Singing Nun*. (Courtesy of artist Gary Schermerhorn.)

Two

THE STORYBOOK VILLAGE IN THE HILLS

This scenic image tour continues in the picturesque village of Mount Plymouth of the 1920s. It was the era of Florida land speculation, and it attracted investors from all over the world. Planned developments emerged throughout the state. The creative plans for the development of Mount Plymouth brought artist Sam Stoltz's Storybook designs to the area. The first Plymouthonian pictured here, built for Virgil Bolyard of Indianapolis, burned down in 1927.

H. Carl Dann Sr. (above) sits at his log cabin on Troon Avenue in Mount Plymouth, which was built in 1926 and designed by Sam Stoltz. Dann Sr. was born in Orlando in 1884. In the early 1910s, he began to build a real estate empire. By 1925, Dann Sr. owned the largest real estate management business in the area. In 1924, he designed Orlando's famous Dubsdread golf course, which he gave to his son Carl Dann Jr. in 1931. In the 1920s, Dann Sr. became part of a group of investors who formed the Mount Plymouth Corporation to plan and develop a new resort community called Mount Plymouth. Below, three generations of Danns are at the Dubsdread golf course in 1935. From left to right are Carl "Sandy" Dann III, Carl Dann Jr., and H. Carl Dann Sr.

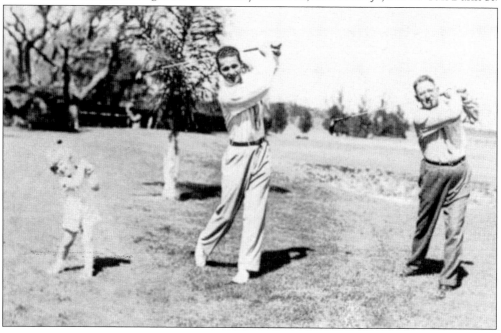

John Thomas Pirie was born in 1827 in Errol, Scotland. He became wealthy with his Carson Pirie Scott and Company department stores in Chicago. He purchased one large tract of land near Apopka and named it the Errol Cattle Ranch and another in the rolling hills near Sorrento, which was called Over the Top Ranch. This ranch would be developed by the Mount Plymouth Corporation and include the Mount Plymouth Hotel and Country Club.

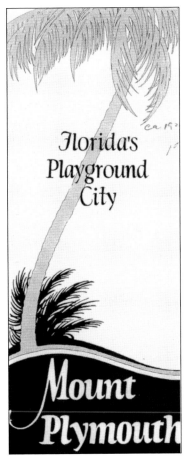

Brochures were distributed in the 1920s by the A.P. Phillips Advertising Agency of Atlanta that promoted the new sports community of Mount Plymouth. Brand slogans such as "Thirty Minutes from Thirty Towns," The Golf Capitol of the World," and "Florida's Playground City" described the new development that would contain 35,000 country estate lots, four golf courses, a 150-room hotel with a clubhouse, bridle paths, and an airfield.

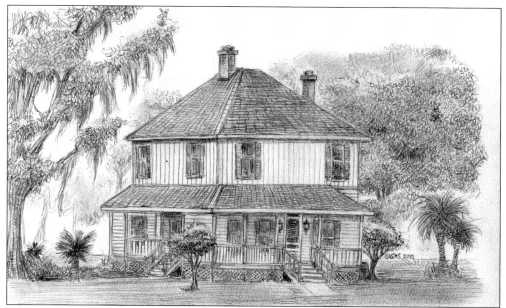

In 1882, Colonel Toole homesteaded near Sorrento, and by 1887, he had built this house on County Road 435. It is recognized as the oldest home in Mount Plymouth. From 1920 to 1928, Annette and Howard Thomas resided in the house. Howard worked for John Pirie's Errol Cattle Ranch. In 1964, Dick and Rebecca "Becky" Calkins became the new owners. The house is still standing. (Courtesy of artist Gary Schermerhorn.)

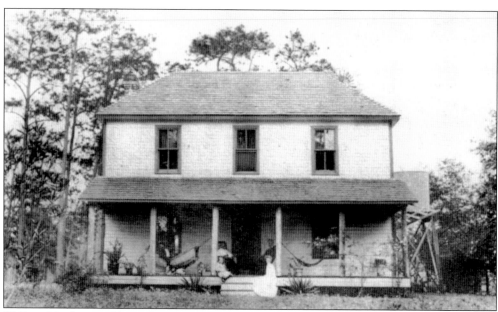

William Hawkins and his wife, Martha (Smith) Homan, built this home in 1886 near Lake Lucy. In February 1902, much of the house and contents were destroyed by fire, but William rebuilt the home. The Hawkins had two children, Harry Benjamin and Olivia. Benjamin married Ellen Thorpe in 1892 and had one child, Ruth Elizabeth. In 1922, Ruth married George Rainey. Later, this home was occupied by the Rainey family.

The Powell family is, from left to right, Herbert; Phillips; Gladys; Phillips's wife, Bessie; and Herbert's wife, Mabel. The Powells' parents were Rev. Edward Payson Powell and Lucy Maltby. The Powells were residents of Clinton, New York, and spent the winters at Lake Lucy. Reverend Powell was an author and lecturer who wrote Florida-themed articles for various publications, including a series for *The Outing Magazine* called "Old Florida Tales."

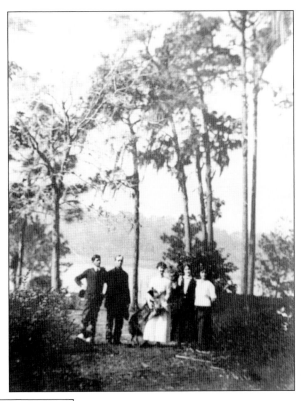

Pictured is the home of Rev. William G. Brooks (1824–1902) on Lake Lucy. Reverend Brooks, a Christian Universalist minister, was married to Lucy Ann (Wright) Morey. Brooks arrived in 1881, and his wife, four daughters, and a son joined him the following year. He was a Mason and a war veteran in the Grand Army of the Republic. Lake Lucy, originally called Lottie Pond, is spelled Lake Lucie today.

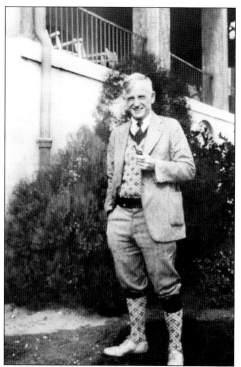

Sam Stoltz was born in 1876 in Pennsylvania and raised on a farm in Nebraska. He studied commercial art in Chicago. Stoltz became a builder, designer, and a self-taught architect. He moved to Orlando in 1925 with his wife, Patti Jo Walker—his favorite art model. His attentions turned to Mount Plymouth, where he created his most popular Tudor-style homes, dubbed the "Plymouthonians." Stoltz passed away on December 10, 1952.

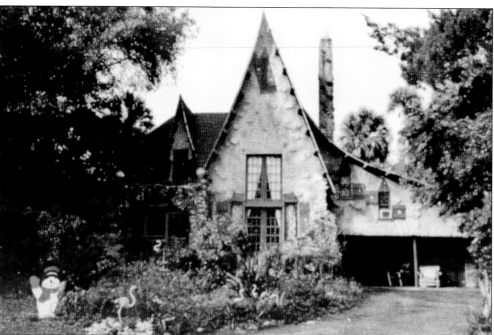

This Storybook house by Sam Stoltz was located on Ridgeview Avenue and Brassie Drive and was known as the "Plymouthonian 2." The home was built in 1929 for Chicago newspaper owner Graves Whitmire. The front gable, with a 15-foot-high peak, housed a cooling chamber. The rock for the massive fireplace was imported from Whitmire's estate in Illinois. Grace and Alfred Schrupp purchased the house in 1935 and made several alterations.

Blarney Castle by Sam Stoltz featured a steep front gable, Gothic arched window openings, cypress woodwork, a corner ceiling-high fireplace, steps that were modeled after those at Bridget's Wall in Ireland, and a conical medieval tower similar to the real Blarney Castle. The first owner, Chicago real estate man Edward A. Carney, whose wife refused to live there, had opened the house with a St. Patrick's Day dance in 1928.

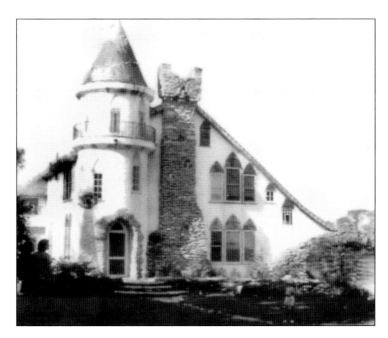

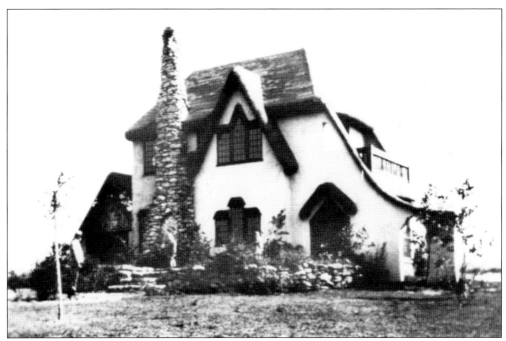

This Plymouthonian on County Road 435 was built in 1926. The original owners were a family named Ellis. The Bolyard and Schrupp families also lived there. About 1945, June and Clifford Bishop purchased the house and had postcards printed. The description reads that it is often called the Hansel and Gretel House, and people are so enchanted by the beauty of this exotic home, they often stop by to take photographs.

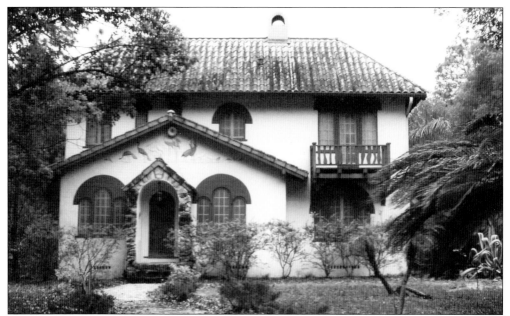

This home by Sam Stoltz, located on Overbrook Drive, was built in 1927 for Elizabeth and John Welch. Though Stoltz's homes retained the Hollywood Storybook ambience, for homes like this he coined his own design style, "Spanish Orlando," which was an interpretation of Mediterranean Revival. The Simpson family of Mount Dora owned this home for 25 years. Martin and Janet (Turner) Lieggi purchased the home on January 3, 2014.

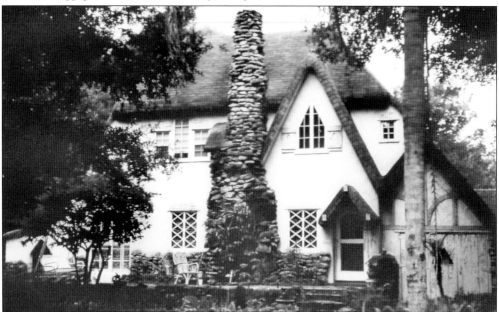

This Sam Stoltz home on Interlachen Drive was built in 1926 for the George Cornelius family of Indianapolis. Legend has it that Stoltz told stonemason Oscar Torbert to build the chimney crooked. A critic, possibly Stoltz himself, felt Torbert had overdone it, but Cornelius purchased the house because he liked the chimney. Maj. Joe Story and his wife, Catherine, bought the home in 1946 and lived there for more than 40 years.

Pictured are the remnants of a fountain designed by Sam Stoltz and built by stonemason Oscar Torbert. The fountain originally had bird sculptures on top and was located on Interlachen Drive. The fountain was the centerpiece of Bessie Park and Gardens, near the Mount Plymouth golf course. With the decades passing and the golf course gone, the fountain's remains are threatened by home construction. Relocation and reconstruction are planned.

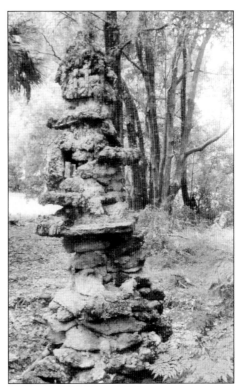

Sunken Gardens was a water feature and popular tourist attraction for the guests of the Mount Plymouth Hotel and Country Club. The team of Sam Stoltz and Oscar Torbert built the splendid gardens, which were originally located near the golf course. Lake County Parks and Trails have begun restoration and preservation of the historic site by request of the Mount Plymouth Land Owners League and the East Lake Historical Society.

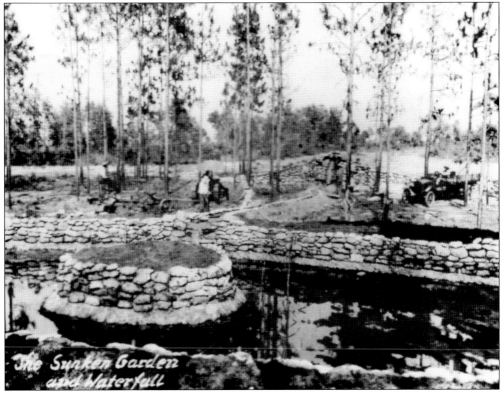

The Sunken Garden and Waterfall

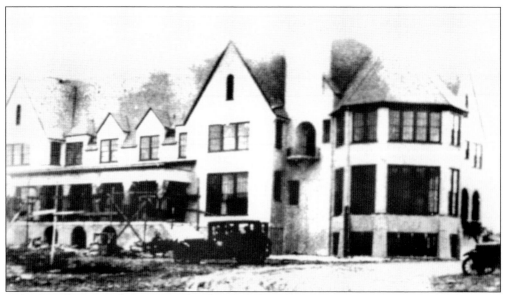

Orlando architects Luther Townsend and A.E. Arthur were commissioned by the Mount Plymouth Corporation to draw plans for the Mount Plymouth Hotel and Country Club. The design was to include architectural features of the Royal and Ancient Golf Club of St. Andrews. High gables, dormers, octagonal-shaped rooms, twin porticos, and chimneys with spiral ribbon patterns were incorporated into the layout. Architect Sam Stoltz designed the south wing. The best workmen from all over the world were hired to work on the hotel. The contract to build the hotel was awarded to Trimble Construction in July 1926. Beams and columns were cut from the trees on property, and sand to make cement was dredged from a nearby pit. Fifty-six staff members from kitchen to maids to administration were hired. Gardens with fresh vegetables and flowers were grown on-site.

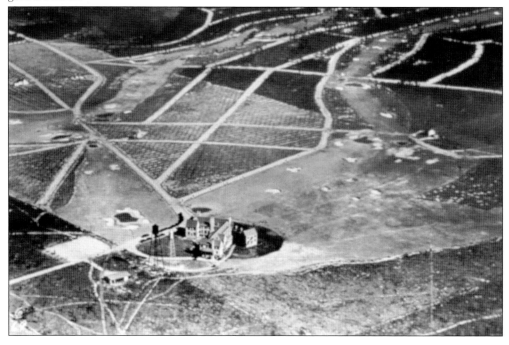

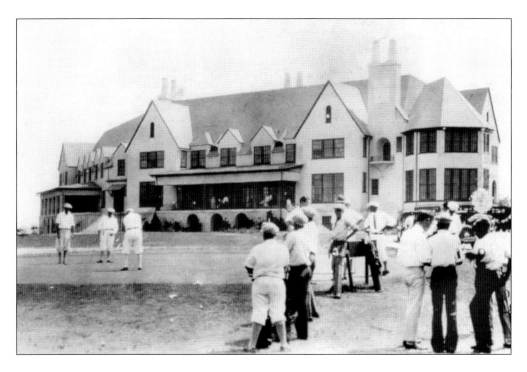

The Mount Plymouth Hotel and Country Club opened for business during the 1926 season, which lasted from December 15 to Easter Sunday. The famous and infamous wintered at the elegant new sports club, where golf (above) was a focal point. Golfing legends Walter Hagen and Lecia Mida were regular visiting players. Returning guests included baseball greats Babe Ruth and Joe Tinker, popular singer and radio personality Kate Smith, and Chicago gangster Al "Scarface" Capone. H. Carl Dann held lectures in the library, attended by notables of the business and professional world. Patrons of the hotel were able to taxi their planes (below) to the hotel. For the convenience of the guests to have their aircraft serviced or repaired, a hangar was built behind the hotel.

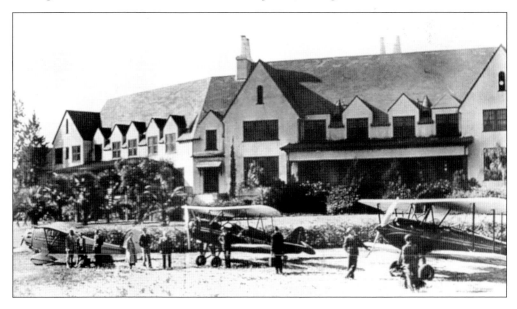

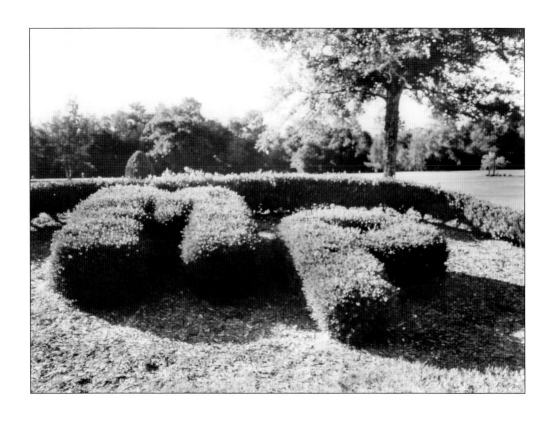

The Oak Hill Golf Course, which opened in 1925, came under new ownership in 1978. With the purchase by Hampton Enterprises Inc., the golf course received a new name—the Mount Plymouth Golf Club. Improvements were made, and an annual invitational tournament was held. This unique golf course featured an unusual layout in that no two fairways ran parallel to each other. The golf course is no longer in existence.

The glory days of the elegant and glamorous Mount Plymouth Hotel and Country Club came to an end in the 1950s. In 1959, the hotel was converted to a private college preparatory school for boys by Col. L.E. Allen and Gen. T.L. Alexander. The school was named Florida Central Academy. In the 1980s, the school had financial problems, and in June 1983, it was closed. The photograph above features students and families gathering for the 1980 graduation commencement. The photograph below is of the staff at the academy, with popular cafeteria personnel worker Ina Klein standing fourth from right.

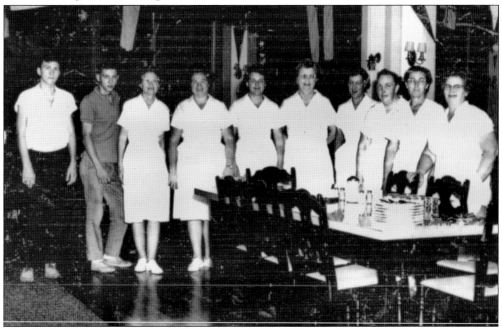

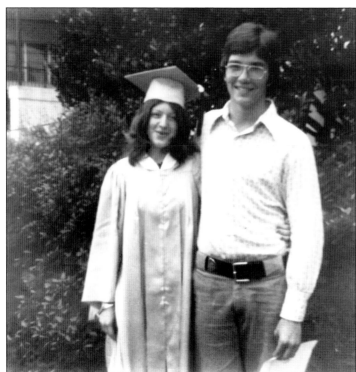

In 1970, girls were able to attend Florida Central Academy. According to Judy Fenby (left), "It was a little nerve racking when you would be standing outside a classroom with eighteen teenage boys and one girl, but it did not take long for everyone to blend and become friends. FCA was very much loved by all the students." Fenby is pictured at her 1973 graduation with her friend Gerald Aldrich.

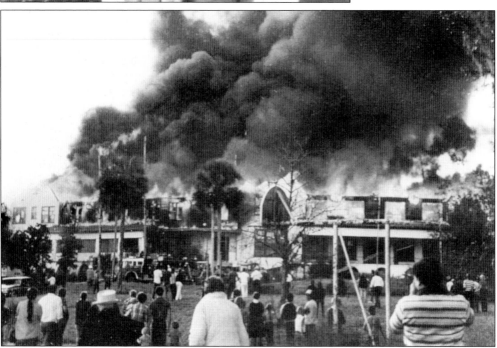

On January 6, 1986, the Mount Plymouth Hotel, and later the Florida Central Academy, was burned down by vandals. Legendary tales of the rich and famous who vacationed at the hotel as well as fond memories by students of their beloved alma mater are all that remain. The fire could be seen as far away as Sanford—15 miles away. After the fire, the remainder of the building was razed.

The Church of God was constituted in 1936. Services and meetings were initially held in the homes of its members. A hush harbor was erected and used from 1936 to 1938 and then a small rectangular frame building was constructed and dedicated. The church's first pastor was P.C. Hickson, who served from 1936 to 1940. Pastor T.H. Wilcox from Sanford succeeded Pastor Hickson in 1940. (Courtesy of Florida Memory.)

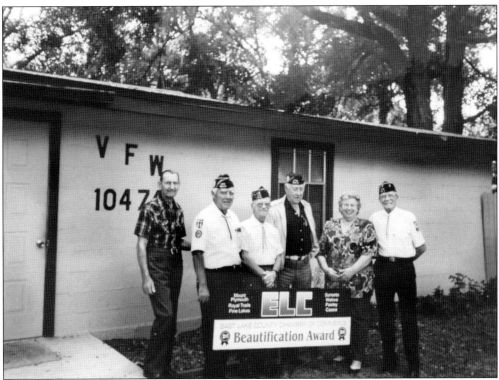

The Mount Plymouth VFW Post 10474 received the Beautification Award from the East Lake Chamber of Commerce after painting the hall and planting flowers in front of the building. Pictured are, from left to right, Harold Beatty; Dan Sabin; Teddy Kaufman; unidentified; Maggie Fisher, the administrative assistant for the chamber of commerce; and Bud Hipple. The VFW closed in September 2009.

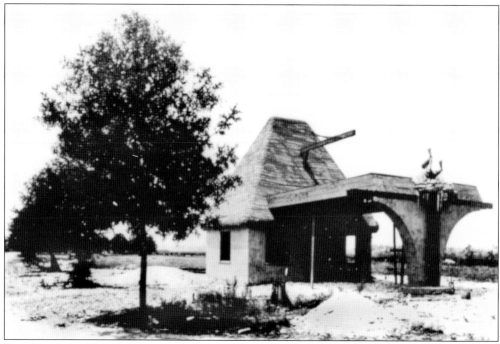

The first Mount Plymouth service station was located at the southwest corner of State Road 46 and County Road 435. It was owned by Leon E. Gulledge (1922–1991) and his wife, Viola (1919–2011). The station's design and architecture were attributed to artist Sam Stoltz. The Gulledge station was torn down in 1957.

In 1986, the county commissioners merged the Mount Plymouth and Sorrento fire departments to form the East Lake Fire District. The Mount Plymouth Fire Department at the time was better equipped than Sorrento's. Mount Plymouth's fire chief, Ed Spann, became the chief of the new fire district, and Sorrento's chief, Ron Locke, became the assistant chief. The new consolidated firefighting force started with 75 volunteers and 12 trucks.

Dorothy "Dot" and George Pegues were married in 1954. They lived in Apopka, where they raised two sons. After George retired from the Orlando Police Department, they moved to Mount Plymouth. George became a truck driver, and Dorothy worked in real estate. She served on the boards of the chamber of commerce and East Lake Historical Society. They both passed away on April 1, 2020, just several hours apart.

Ann Kaufman arrived from Pennsylvania in 1953 and worked at the Mount Plymouth Hotel as a waitress. During the off-season, Ann; her husband, Ted; and their two children lived in the hotel. When the guests returned, they would stay in a Stoltz house. Ann passed away on May 22, 2022. Robert Soukup was vice president of the Florida Central Academy for 20 years under academy president Col. L.E. Allen.

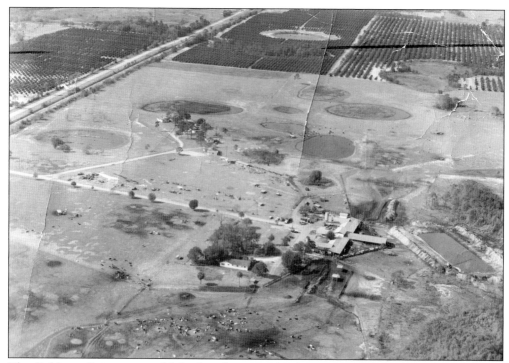

The Oaklawn Dairy was established in the 1960s by the Hammond family. Elbert "Bill" and Margaret Cammack purchased Oaklawn in 1975. They had owned a dairy in Geneva, Florida, since 1955, known as Fairglade Dairy. The Cammacks moved their 1,000 cows and the Fairglade name to the new 800-acre farm. The Cammacks' daughter Catherine Cammack Hanson still resides on the dairy farm she once managed. (Courtesy of Catherine Hanson.)

Catherine Hanson, pictured in 1990 with her children Scott (sitting), Keith (left), and Leslie (right), is one of Lake County's most remarkable assets with a legendary list of honors, awards, and accomplishments. Catherine was the first woman elected to Lake's board of county commissioners, serving for 16 years. Included among her dozens of civic participations are Citizen Committee for Children, Elder Affairs Council, Wekiva Protection Committee, and Cultural Affairs. (Courtesy of Catherine Hanson.)

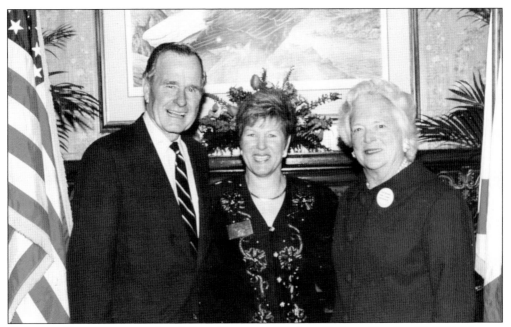

Catherine Hanson is pictured with Pres. George and Barbara Bush on October 10, 1994. Hanson was the first inductee of the Lake County Woman's Hall of Fame, and among her many other awards are Mount Dora Citizen of the Year, East Lake Chamber of Commerce Founders Award, Living Legend Eustis Historical Society, Friend of Hospice, Outstanding Leadership in Environmental Planning, and Altrusa Woman of Achievement. (Courtesy of Catherine Hanson.)

On February 22, 2019, the Mount Plymouth Land Owners League held a yard sale at the Catherine Hanson Real Estate office. The league, established in 1972, is a not-for-profit corporation. Its purpose focuses on the orderly growth of Mount Plymouth and pleasant living conditions as well as preserving the ecological environmental balance. Members are, from left to right, Joann Maynard, Catherine Hanson, Brenda Canada, and Karen Moss.

Mildred "Brownie" Brownsberger, pictured in 1977, was a historian, secretary, and librarian for the Lake County Historical Society in the 1980s and a columnist for the *Mount Dora Topic*. In an article she wrote in 1976, she reported finding the ruins of the house believed to be the First Plymouthonian. From 1955 to 1956, Mildred and her husband, Harry, rented the Blarney Castle. She passed away in 1999.

Frances L. "Fran" Wright, pictured with reporter Ramsey Campbell, was the first female firefighter in the Mount Plymouth Fire Department. She was born in January 1932. Wright was a Sorrento/Mount Plymouth historian who began compiling a history of the area in the 1970s. She wrote feature articles for the local newspapers. Ten years after her passing in 1985, her extensive research collection was purchased at a garage sale for $5.

Kathy Horton, pictured with her daughter Samantha in 1986, moved with her family from Northlake, Illinois, to Oak Springs Mobile Home Community on County Road 435 in February 1985. Horton worked for Robin's Restaurant in Sorrento from 1985 to 1988. From 1989 to 1996, she worked at Sandy's Salon in Sorrento. Horton is a successful businesswoman, who owned Hair Fair Designers in Eustis from November 1996 until May 2021. (Courtesy of Kathy Horton.)

In 1981, Terry and Pat Scott moved to Winter Park from Ohio with their three sons, Ted, Tom, and Tim. Soon afterward, Pat traveled to Mount Plymouth to inspect a refurbished superette. By April, they owned the Mount Plymouth Grocery. Scott Park in Mount Plymouth was named for the Scott family. Pictured in this 1997 photograph are, from left to right, Pat Scott; Pat's dad, Leland Lyons; and Terry Scott.

In November 2020, Mount Plymouth Land Owners League (MPLOL) held its first annual Neighbor to Neighbor Food Drive. The league partnered with the Mount Plymouth IGA and the local community to help replenish the food bank at the First Baptist Church, which had been impacted by the COVID pandemic. Pictured are, from left to right, Fred Antonio, MPLOL member; Dwayne Reichert and Sheila Keeney, IGA employees; and Frances Nipe, MPLOL member.

Nisha (holding scissors) and Nakul Patel (striped shirt) are shown at the 2011 ribbon cutting of their remodeled IGA grocery. The Uganda-born Patels became owners of the Mount Plymouth IGA in 1998. They are highly oriented to the needs of the community. During holidays, the Patels donate food bags to needy families, sponsor many fundraising events, and have raised money for Camp Challenge and the American Cancer Society's Relay for Life.

Camp Challenge was established in 1961. The camp is owned and operated by Easter Seals Florida Inc. Derek Fennell, pictured with his mother, Teresa Fennell (right), was the camp's First Ambassador. Derek was born in 1981 and passed away at age 23, leaving beautiful memories in the hearts of those who loved him most. Camp Challenge provides a unique experience for children over six years of age and adults with disabilities and special needs to participate in camping activities, engage in social interaction with peers, and achieve life-changing experiences. Campers engage in a variety of enriching outdoor activities in a natural Florida setting. Below, in 1961, only hygiene facilities and the pool were constructed. A circus tent was borrowed for a dining hall, and the 108 chartered campers and all staff lived in borrowed squad tents. (Both, courtesy of Camp Challenge.)

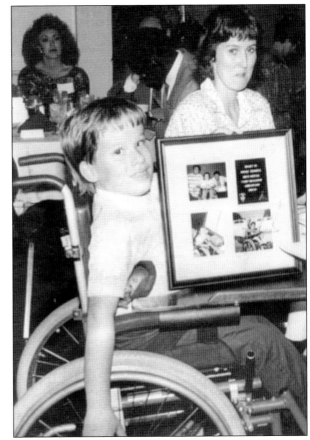

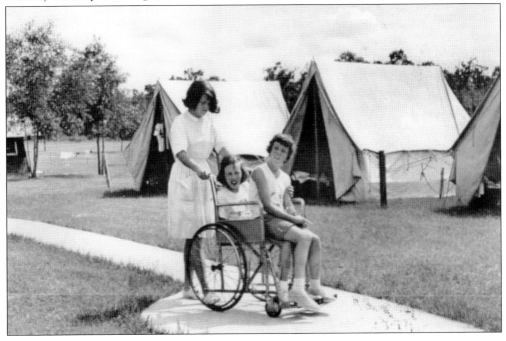

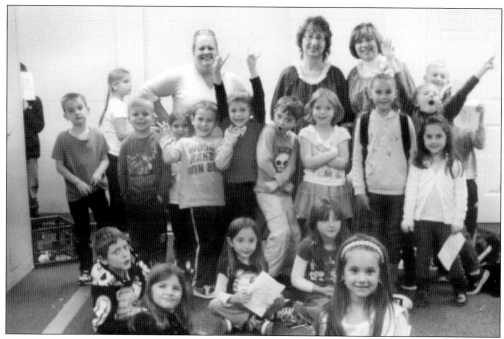

On January 2, 2014, East Lake Historical Society's education committee presented its historical booklet to the children at Building Futures Academy aftercare program. Although Florida history is taught in school, very little focuses on local history, which the booklet provides. The three presenters are, from left to right, Elizabeth Steele from East Lake County Library; Maureen Miller, committee chairperson; and Barbara Tenney.

Edward Olszewski Von Herbulis and his wife, Theresa, owned a jelly store at the northwest corner of State Road 46 and County Road 435. They stocked many assortments and colors of jelly—from deep red to dark green. The Von Herbulis family made their own jelly, which they shipped to grocers throughout Central Florida in their Model B Ford truck. They also sold watermelons in season at the jelly store.

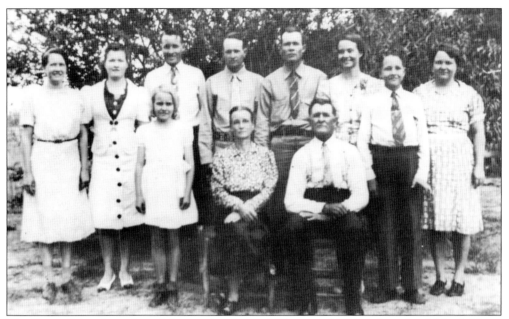

The Bagwell family is, from left to right, (sitting) Elzora and Wiley; (standing) Hazel, Nina, Edith, Clayton, Bethel, Arlen, Zelma, Hubert, and Corine. Bethel and his son-in-law Joe Chavis established a cypress sawmill in 1973. In 1932, Elzora, along with her three daughters Corine, Zelma, and Hazel and Pearl Haskins, started the Mount Dora Church of Christ.

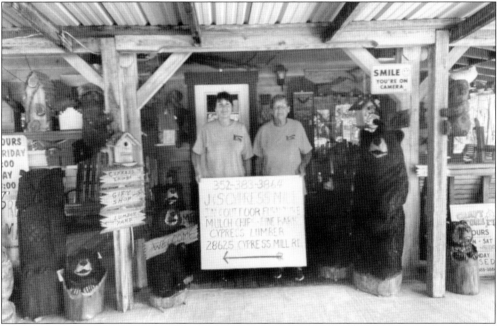

Cypress Things by J&S Cypress is located at 28625 Cypress Mill Road. Pictured are Tracey Chavis (left) and Ethel (Bagwell) Chavis (right). They, along with Ethel's husband, Joe, a cofounder of the mill, and Tracey's husband, Shane Chavis, operate the sawmill. The mill specializes in cypress lumber, country crafts that range from small figurines to picnic tables, outdoor and indoor furniture, mulch, chips, and pine bark.

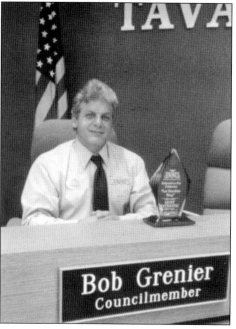

Doris Bernice (Lewis) McDonald is pictured with her sons, from left to right, Jack, Bert, Joe, and Wheeler. Doris was born in Cuba in November 1919 and moved to the United States in 1927. She met Donald McDonald, and the couple married in 1940. Doris attended the Sorrento Church of God and was well remembered as a very kind, sweet lady. Doris and Donald are interred at Seminole Springs Cemetery.

Bob Grenier moved to Mount Plymouth from Northlake, Illinois, in 1985. He is a retired area mechanic for Walt Disney World, where he worked for over 25 years. Grenier served on the Tavares City Council from 2008 to 2018 and was re-elected in 2022. In June 2019, as the curator for the Lake County Historical Museum, Grenier was awarded, by the State of Florida, the General Edmund Kirby-Smith statue from National Statuary Hall in Washington, DC. (Author's collection.)

Three

THE ROYAL SETTLEMENT

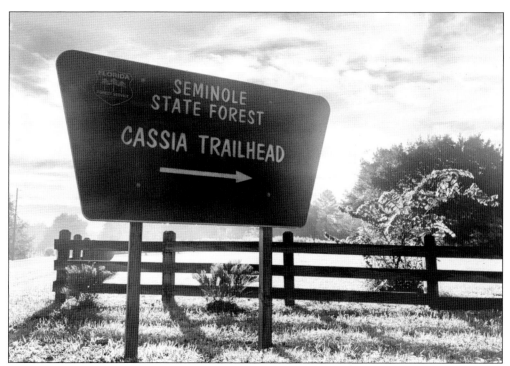

The sun rises at the Cassia Trailhead of the Seminole State Forest, a gateway to a historic village on State Road 44 that almost received the name Rosedale, Owensville, or Royal Villa. The pleasantries at a picnic held by the pioneering residents of the friendly settlement prompted the citizens not to name it after a particular family but to call it by a suggested name—Cassia. (Author's collection.)

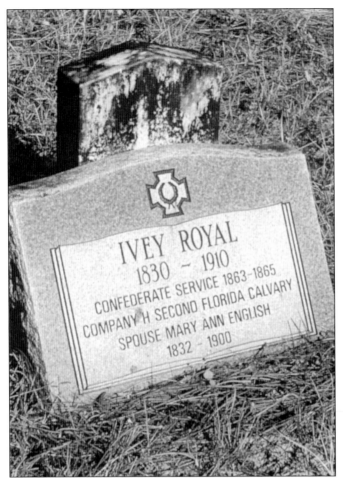

Ivey Royal and Mary Ann (English) Royal, with their three-year-old son Alonzo, arrived from Georgia around 1860. The journey took weeks in a covered wagon with a milk cow in tow. Soon after they arrived, Ivey traveled to Volusia and enlisted in the Confederate army. Ivey supplied his own horse, rifle, and uniform. With Ivey away, Mary Ann fought the battle of the wilderness. While pregnant for a second time, she fended off a pack of wolves by throwing firewood at them until she was able to get her son and cow into the house. When Ivey returned home, he learned that he was the father of twin boys—Warren and Albert. In 1887, Ivey was appointed the first Lake County commissioner from the Cassia district. Shown in the drawing below are brothers Alonzo (left) and Warren (right) Royal. (Left, author's collection; below, courtesy of artist Gary Schermerhorn.)

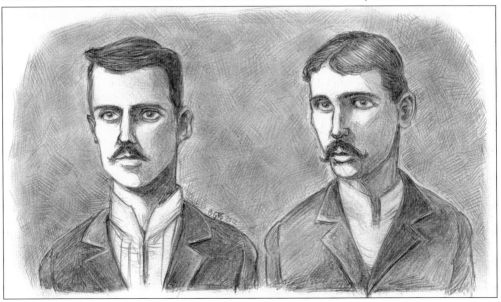

Ivy Royal Douglas (left) was born in Cassia in 1887. She was the daughter of Alonzo and Annie Elizabeth (Killebrew) Royal and named for her grandfather Ivey Royal. Ivy married Frank V. Douglas in 1916. They had a son named Richard Alexander. Ivy served as Cassia's third postmaster. In 1956, the county commissioners designated her an election clerk for Cassia Precinct 4. Ivy passed away in 1968.

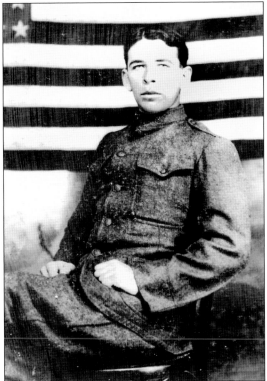

Dixie Elliott Royal, pictured in his Army uniform in 1917, was born in Cassia in October 1889. He is the son of Albert and Carrie May (Harper) Royal. He enlisted at Jacksonville in December 1917 and served overseas from April 1918 until September 1919. He had worked at Parker's Packing House in Sorrento. Dixie married Ettie Lanora Miley in May 1928 in Hillsborough. They had two children, Dixie and David.

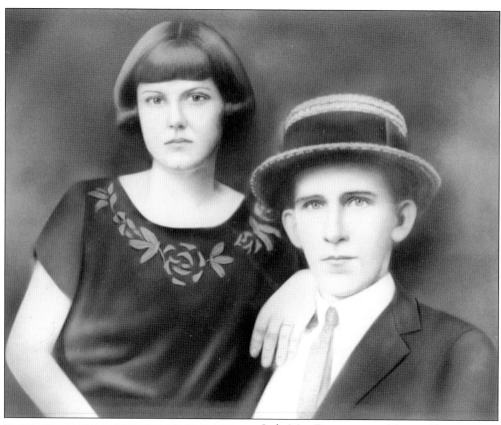

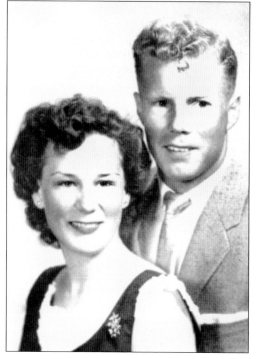

Lola Mae Dunn married farmer Ernest Royal on December 23, 1924. Lola Mae died on December 31, 1929, at the age of 21. They had three children—Thelma, who was almost five when she passed away; Alonzo; and Ernestine. Ernest's mother, Annie, helped him raise the children. Ernest became a contractor in the timber industry and a rancher. He moved several times between Cassia and Sorrento.

Alonzo "Lonnie" Eugene Royal, named for his grandfather, was born in Cassia on May 25, 1928. Lonnie, nicknamed "Buster" when he was a baby, was married to Nana Bryan on May 8, 1956. They lived in South Florida for 28 years and moved to Sorrento in 1993. They had three children, Donna, Lisa, and Tracy. Buster, an Army veteran, contractor, and building inspector, passed away in February 2015.

At right, Dixie Jr. and David Royal, the sons of Dixie and Carrie May, are pictured in this c. 1935 photograph at their home in Sorrento. Dixie was born in 1932 and David in 1934. Dixie served in the Air Force and was a citrus grower and production manager for Golden Gem. He was married to Mary Alice Brooks, and they raised three children, Richard, David, and Debbie. David served in the US Army and was an anesthesiologist in Lakeland. He was married to Army Medical Corps nurse June Mohler. They had two sons, Stanley and Dwight. Below, Dixie is pictured at the Heritage Festival in 2021.

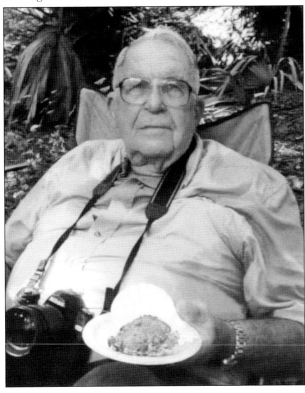

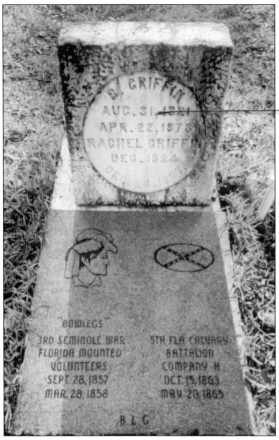

Rachel and Ben Griffin (left) settled in Cassia in 1857. From September 28, 1857, until March 28, 1858, Ben served in the Florida Mounted Volunteers during the Third Seminole War. In October 1863, he traveled to Volusia, across the St. Johns River, and enlisted in the Confederate army. He served in 5th Florida Battalion, Company H under the command of Capt. Melton Haynes. His cavalry unit engaged in skirmishes throughout Florida, including Green Cove Springs, Welaka, and Gainesville. He was paroled on May 20, 1865, in Waldo. Ben passed away on April 22, 1873, and is buried at Seminole Springs Cemetery. Rachel passed away Christmas Eve 1887. Pictured in 2000 below are five Griffin brothers, great-grandsons of Ben and Rachel. They are, from left to right, Ben, Woody, Carl, Herman, and Richard. (Left, author's collection; below, courtesy of Lake County Historical Society.)

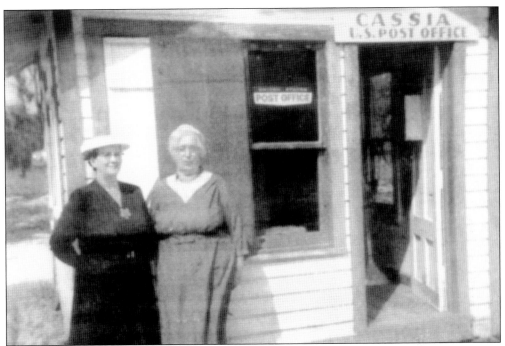

The Cassia Post Office was founded on March 10, 1884. The first postmaster was Lawrence Owens. All subsequent postmasters were women. In 1931, there was a robbery in which the postmaster, Anna T. Lawrence, and her husband were killed. The building was set afire and destroyed. The next post office (above) was built by Grover and Mittie Smith. It was built on the site of the original post office, with Mittie as the new postmaster. When she retired, Ernestine Gnann became Cassia's last postmaster. On June 17, 1966, the post office was redesignated and became a rural branch located at the Tanner Grocery. Ruth Tanner became the clerk in charge. Pictured below is an August 1938 photograph of Dorothy's Store; Dorothy is sitting in the doorway. (Both, courtesy of Cassia Community Club.)

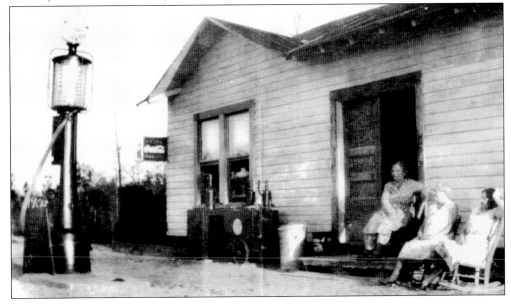

Lawrence J. and Rachel Owens, pictured in 1920, were citrus growers. Their trees were devastated during the six-week freeze between December 29, 1894, and February 7, 1895. Lawrence told a *Times-Union* correspondent that "he couldn't tell what extent the orange trees were injured, but his trees commenced to put on a fine growth, also a bloom, before the second freeze set in." (Courtesy of Lake County Historical Society.)

George J. Dykes was born near Altoona in 1876. He married Lena B. Walden in 1902. Dykes began his 18-year career as an educator in 1896 at the Cassia School, where he taught for five years. Dykes also had a long career in public office, serving as the Lake County treasurer and clerk-assessor for Eustis. In 1928, he was elected clerk of the circuit court. (Courtesy of Lake County Historical Society.)

Ernestine Royal was born August 1926 in Sorrento. She attended Sorrento School. Her parents, Ernest and Lola, moved the family to Cassia. In 1965, Ernestine was appointed Cassia postmaster. She married Robert Gnann and moved to Mount Plymouth. They made a career at the Lake County Sheriff's Department. The Gnanns had a son, Claude Allen, and a daughter, Candy Lou. Ernestine had one daughter, Linda Beck, from a previous marriage.

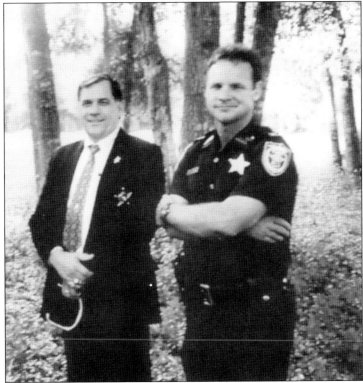

Claude Gnann (right), pictured with Sheriff George Knupp Jr., was born in 1949. He was a Navy veteran who served in Vietnam from 1969 to 1973. In 1977, he began his career with the Lake County Sheriff's Office, and by 1997, he had risen to the rank of major. He retired in 2004. Major Gnann passed away in 2005. A stretch of State Road 44 is designated the Major Claude A. Gnann Memorial Highway.

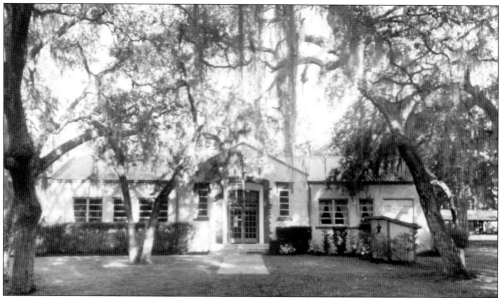

The Cassia Community Club, built in 1926, started as a two-room schoolhouse called Cassia School. The school was constructed for $10,000 on land donated by Warren Royal. Cassia School closed its doors in September 1953, and the Cassia students had to attend school in Eustis. The Cassia Community Club leased the vacant school in 1958 and purchased the building and surrounding five acres when the Lake County school board put it up for sale in 1964. The Cassia Community Club submitted the highest bid of $2,250. At the time, the club had $879.26 in the building fund, so it had to secure a loan. Below, students attending the Cassia School during the 1945–1946 school year are, from left to right, Dewayne Spears, Millard McClarty, Juanita Lee Hall, and Janell Funderburk. (Courtesy of Cassia Community Club.)

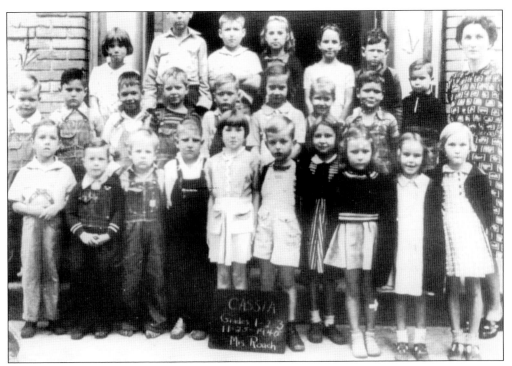

This November 25, 1940, photograph of Cassia's first through third grade classes features teacher Ruth Patterson Roach. Ruth; her husband, Clifford A. Roach; and son Clifford P. had lived in Palm Harbor in Pinellas County with her mother, Lavinia Patterson, prior to their move to Eustis on Ambassador Avenue. She was a college graduate who embarked on a career as an educator. (Courtesy of Cassia Community Club.)

Stanley "Stan" Eugene Bainter was a Republican legislator who served in the House of Representatives from 1986 until 2000. Bainter was born in 1931 in Illinois and moved to Florida in 1959. He and his wife, Marilyn, had three children, Jon, Dara, and Patrick. Bainter was an insurance agent and a Korean War veteran. He passed away in 2018 and is buried at the Florida National Cemetery. (Courtesy of Florida Memory.)

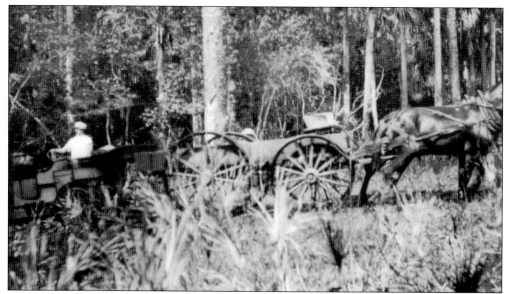

A horse and buggy rescue a horseless carriage from Blackwater Creek. The creek flows about 20 miles from Lake Norris to the Wekiva River, with a portion of the deep-red, tea-colored water winding through Seminole State Forest. The dark water comes from the tannic acids of rotting vegetation. In 2000, Congress designated it a "Wild and Scenic River System." The Timucuans once traveled Blackwater Creek in their dugout canoes.

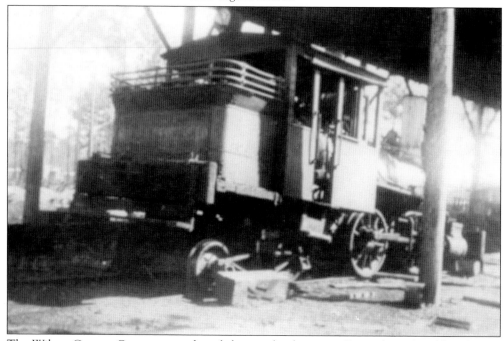

The Wilson Cypress Company purchased thousands of acres in Cassia from the old Rodriguez Land Grant that was acquired by the Spanish prior to 1821. At its peak, the company was the second-largest cypress mill in the world and owned more than 100,000 acres of original growth cypress across 10 Florida counties. Pictured is one of the company's locomotives being worked on in an open-air shop. (Courtesy of Florida Memory.)

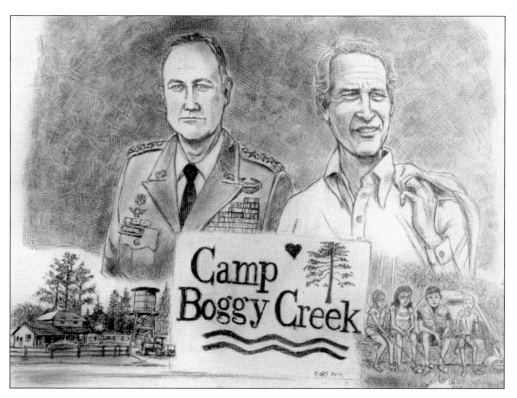

Camp Boggy Creek was founded in 1996 by Gen. H. Norman Schwarzkopf (above, left) and Paul Newman (above, right) with one simple premise in mind—that every child, no matter their illness, could experience the transformational spirit and friendships that go hand in hand with camp. The camp, pictured below, is located in Cassia. Their mission is to offer a unique experience for children with serious illnesses to experience joy and happiness in a camp setting. Part of the camp's mission is to provide campers with inclusive activities that foster a creative and fun atmosphere, and through these activities, they encourage independence and choice. Lake County commissioner Catherine Hanson was instrumental in bringing Camp Boggy Creek to Lake County. Her research and strong support allowed the camp to be constructed here. (Above, courtesy of artist Gary Schermerhorn.)

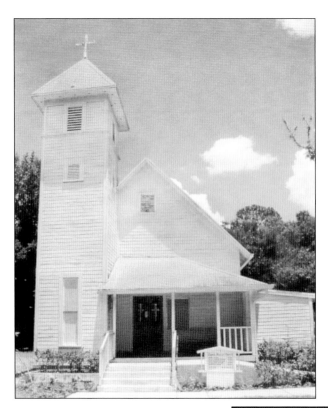

Cassia Baptist Church, built in 1889, is located on Cassia Church Road. Rev. D. Palmer served as the first clergyman from 1889 to 1900. Country singer Michael Ray's 2021 recording of "Holy Water" is the story of a Florida preacher who also ran moonshine. Ray's great-great-grandfather helped build the church, his father was a preacher there, and legend has it that his grandparents ran moonshine. (Courtesy of Cassia Community Club.)

Before hiking or paddling through the East Lake County wilderness, visit the annual Cassia Day festival at the Cassia Community Building. On the fourth Sunday of October for over 60 years, the popular event attracts visitors from all over Central Florida. The festival features some of the biggest acts in bluegrass and country music, which included Eustis-born country artist Michael Ray Roach. (Courtesy of Cassia Community Club.)

Four

SCENIC SPRINGS, GHOST TOWNS, AND AN ANIMATOR'S INSPIRATION

The trail through the East Lake County wilderness brings one to the refreshing Clay Springs, seen here around 1900. Billed as the region's first tourist attraction, it had a railroad depot, dance pavilion, bathhouse, a hotel that overlooked the springs, and a rail toboggan ride that poured riders into the springs. Visitors from all over America came to bathe in the "health-giving" waters. In 1906, Clay Springs became known as Wekiwa Springs. (Courtesy of Florida Memory.)

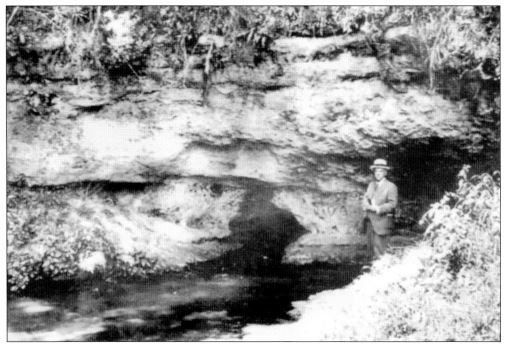

In 1910, Dr. Howard Kelly (pictured), cofounder of Johns Hopkins Hospital, visited Rock Springs where he drank the sweet water that came from a mysterious cave. He wrote that the cave and its spring waters "were part of God's open book of nature." On May 5, 1927, after he refused an offer of $200,000, Dr. Kelly donated his land, which included the springs, to Orange County. (Courtesy of Florida Memory.)

Seminole Creek, pictured in 1910, is a 3.9-mile-long creek. It is a tributary of Blackwater Creek that runs through the Seminole Swamp—all part of the Wekiva River watershed. In 1823, five years after the First Seminole War ended, the Treaty of Moultrie Creek was signed between the US government and the Seminole tribe. It established a four-million-acre inland reservation that covered most of present-day Lake County. (Courtesy of Florida Memory.)

The Wekiva River, pictured in 1910, is one of the few remaining near pristine river systems in Central Florida. Its headwaters begin at the confluence of Wekiwa Springs Run and Rock Springs Run. Waters creating the Wekiva arise from the Floridan aquifer as clear, freshwater springs. Wekiva is the Creek word for "running" water (i.e., the river), and Wekiwa is the Creek word for "bubbling" water (i.e., the springs). (Courtesy of Florida Memory.)

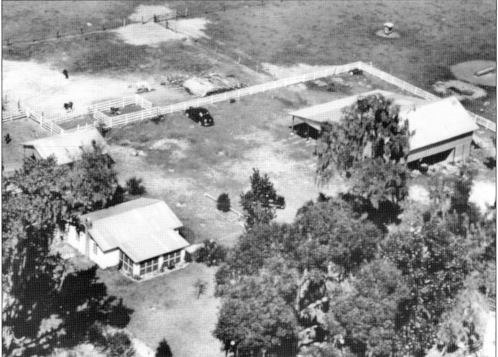

Dr. Louis R. Bowen's ranch spread over 2,000 acres, with hundreds of acres of groves. Dr. Bowen began practicing medicine in Lake County in 1934, directly after he finished medical school. Though a surgeon, he treated every form of ailment. Dr. Bowen retired to his ranch after 47 years in practice. The ranch, pictured in 1952, was managed by Alto and Ruby Smith from 1949 to 1965. (Courtesy of Shirley Meade.)

Tony Moore (left) was born in Georgia in 1938. After a tour in the Navy from 1958 to 1963, Moore became a land and construction surveyor for over 30 years. In his retirement, he was a volunteer with the Wekiva Wilderness Trust. In April 2008, while exploring through Rock Springs Run Reserve, Moore discovered an almost hidden grave marker that bore his family name. He continued to search among the grass and found a second gravestone with his family name. Moore never established a family connection. His research led to the rediscovery of the one-time thriving community of Ethel. The Ethel Cemetery today (below) is a one acre fenced site. Research has identified 29 burials to date. During World War II, many of the headstones were said to have been removed by a cattle rancher and dumped into a swamp.

William Shelton Delk was born in 1815. He moved to Florida in the 1840s. In 1854, he bought 3,000 acres of woodlands around Rock Springs in Orange County. Delk hauled supplies to his plantation from Hawkinsville 18 miles away. His 400-acre plantation was the area's largest, and there he grew cotton, rice, sugar cane, and corn. Delk worked the land with his son William, two white laborers, and 19 slaves. During the War Between the States, he supported the Union. In 1863, a Confederate cavalry unit from Lake City arrested him and seized his land. In Sorrento, they camped for the night, and Delk escaped and returned home. Delk died in 1885 at the age of 70 and is buried in Apopka. Below, remnants of the Delk plantation slave quarters are shown. (Below, courtesy of Florida Memory.)

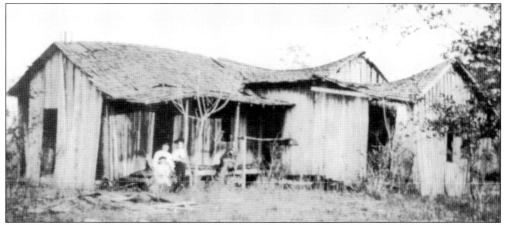

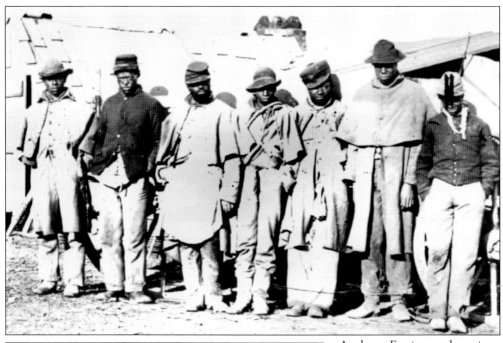

Anthony Frazier was born in Liberty, Georgia, on March 10, 1836. He came to Florida as a slave of William S. Delk's plantation at Rock Springs. After Delk freed his slaves, Frazier traveled to Hilton Head, South Carolina, and enlisted in the Union army on September 14, 1864. He served in the 21st Regiment, Company K, United States Colored Infantry (above). Frazier was discharged on April 25, 1866. He married Mary Ward in Jacksonville on February 2, 1867. The Fraziers returned to the Sorrento area. He became an Orange County commissioner of roads. Frazier's headstone (left) was found on land near Ethel once owned by him but sold in 1885. The state now owns the land, which is known as Neighborhood Lakes. The marker was found during construction of the Wekiva Parkway. Frazier's actual gravesite is still unknown.

Mary Ward (right) met Anthony Frazier when he was a Union soldier in South Carolina. She was younger than Anthony by possibly 20 years. After they were married in 1867, the Fraziers settled near Lake Beauclair in Tangerine. In the 1870s and 1880s, Frazier purchased 120 acres from the US government at $1.50 an acre in Sorrento. They were known in the region as Uncle Pete and Aunt Mary—terms of respect and endearment. The Fraziers had eight children, including youngest child Morton, born in 1888, and pictured below around 1920. Anthony passed away on April 7, 1910. Mary submitted a pension request written on her behalf by Albert Matlack. On December 19, 1924, Mary died of influenza in Sorrento. She was well known in the area as a midwife.

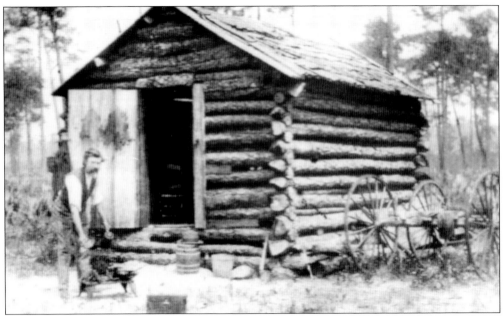

Finley Belshazar Click was born in North Carolina in 1863. He married Margaret Ann "Maggie" Mills in 1887. The Clicks had three sons, Clyde, Clifford, and Carl. Finley is pictured at his log cabin at Ethel in the late 1880s. In 1912, they built a new double-pen, board-and-batten house. Maggie died in 1913. The Clicks received their land grant at Ethel in 1915. Finley later married Emily Hull.

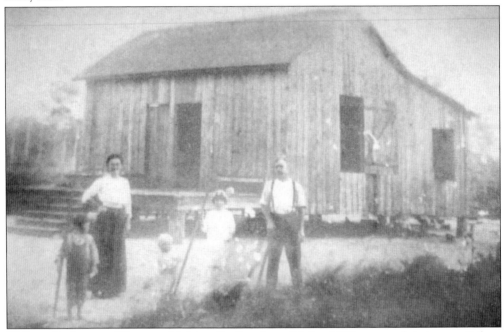

William Darlington Fillmon, with his wife, Etta Jane (Goings) Fillmon, and their sons Robert (left) and Wesley (center) are pictured at their home on their 160-acre homestead at Ethel around 1920. The girl in the white bonnet is "Aunt" Creasy. Another son, William A., died on May 13, 1916, from diphtheria. He was buried the next day at Ethel.

The earliest mention of Ethel School was in November 1893. On August 9, 1916, Eva Shores was appointed the new Ethel School teacher, but she resigned on January 1, 1917, when her pay was cut to $40 a month. Theresa Dawson (second row, left) was then appointed by the district superintendent. In 1918, when her pay dropped to $30, she threatened to quit, so they raised it to $50.

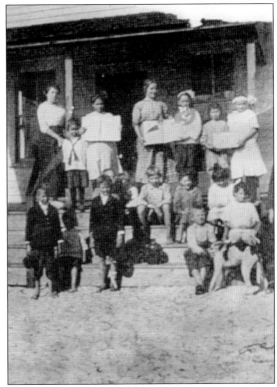

Charles Ray Lewis, pictured with his wife, Maureen, was the great-great-grandson of William and Samantha Delk. Ray's parents were Charles Henry Lewis and Rowena Pearl White. He had a brother named Norman. Charles Henry, whose parents were missionaries, was born in Cuba in 1917. When Charles was 10, his family moved to Ethel. He married childhood friend Rowena in December 1942. Rowena was born in Ethel in 1922.

Don Philpott, born in England, has published over 250 books in his 50-plus-year career. For 20 years, he traveled the globe reporting for Reuters-Press Association prior to establishing Mediawise Communications, an international marketing company. Philpott, along with Shirley Meade and Bob Grenier of the East Lake Historical Society, are working with Robert Brooks, manager of the Wekiva River Basin State Parks, on creating the Ethel Commemorative Trail, which features informational kiosks, historical markers, guided tours, and reconstructed cabins. Philpott serves on the board of the Florida State Parks Foundation and has been a volunteer at Wekiwa Springs State Park for over two decades. Below, Philpott gave a tour to the students of Wekiva Elementary School at Wekiwa Springs on March 25, 2014. (Both, courtesy of Don Philpott.)

Four miles northeast of Cassia on State Road 44 are the communities of Pine Lakes, South Pine Lakes, and Florida Hills. At Pine Lakes, the Bear Claw Ranch and Club was founded by Dr. Clay Reynolds III and his wife, Linda. In 1982, they purchased 160 acres of marshland, and as surrounding areas became available, they purchased those parcels and opened a hunt club. The club's maxim is "We celebrate a rich history of family, friends, and togetherness through our passion for the outdoors and agritourism." A short distance from Bear Claw is Pine Forest Park, a 28-acre Florida scrub-jay management area with the most biologically diverse plant ecosystem in Lake County's park system. Pictured above is the First Baptist Church of Pine Lakes on Huff Road, and shown below is the Royal Trails community, which has deeded access to private Lake Norris.

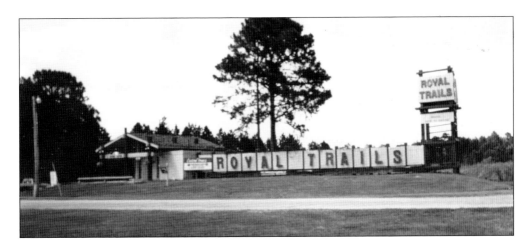

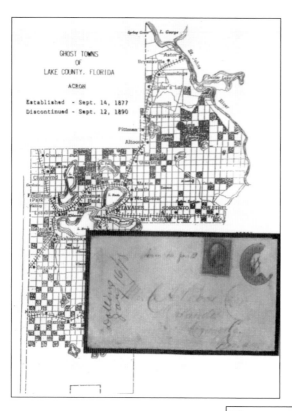

The ghost town of Acron was first settled in 1860. In 1875, the settlement received the name Acron and a post office was opened in the home of John Campbell. A two-story log house was built and used as a Sunday school, church, public school, voting booth, and Masonic lodge. In 1886, a general store was opened by J.C. Hethcox and Jennie Gardiner. (Courtesy of Lake County Historical Society.)

The ghost town of Crows Bluff on the St. Johns River was settled around 1858 by Louis Ballard, Parson Tindle, John Turner, Elish Howard, Bill Lomineck, and E.H. Crow. Crow changed the name to Osceola when he opened a store, except his goods were constantly being sent to Ocala. He then changed the name to Hawkinsville. A toll free bridge to Volusia County was located there. (Courtesy of Lake County Historical Society.)

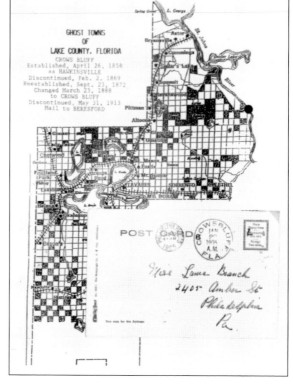

Island Pond was a community settled around 1863 approximately six miles from Sorrento. Local historians believe the settlers were freed slaves from the Delk plantation. The small settlement had a church and two long forgotten cemeteries named Island Pond I and Island Pond II. Eight marked graves were discovered, and through extensive cleanup efforts, 17 more unmarked graves were located. Pictured are descendants of Island Pond families.

Camp La-No-Che is the Boy Scouts of America camp located on Lake Norris in Paisley. It is part of the Leonard and Marjorie Williams Family Scout Reservation campus, which includes Camp Rybolt, Scout Ranch, Adventure Camp, and Camp Pooh Bear. Leonard Williams was a huge supporter of scouting. He managed the Wayne Densch Budweiser distributorship and donated the company's old offices to the Central Florida Council. (Courtesy of Camp Lo-No-Che.)

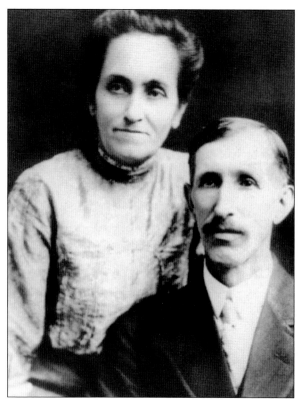

In 1884, Kepple and Mary Disney and their son Elias, along with Charles and Henrietta Call, settled in Paisley. The Disneys returned to Kansas, but Elias remained. In 1888, Elias married the Calls' daughter Flora in Kismet. Elias and Flora (left) were amongst the first recorded marriages in Lake County. After the 1895 freeze, the Disneys moved to Chicago, where Walt was born. Walt visited East Lake County on many occasions to see his aunt Jessie Perkins and cousin Irene Campbell (below). He thought of building Walt Disney World around Paisley, but his aunt was adamant in discouraging that idea. In the 1930s, on visits to his relatives, Walt would sketch the wildlife. *Bambi* and his *True-Life Adventures* series were inspired by visits to East Lake. Walt's grandparents the Calls are among the family members buried at Ponceannah Cemetery in Paisley. (Both, courtesy of Lake County Historical Society.)

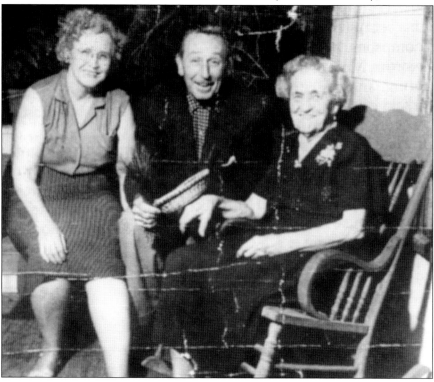

Five

PRESERVING FOR THE
BENEFIT OF POSTERITY

Author Patrick D. Smith describes a person's "sense of place" as being a place one's heart calls home. Traveling through East Lake County, with its rich history and beautiful natural landscape, a genuine sense for its preservation and conservation becomes essential. The East Lake Historical Society was formed for this purpose—to preserve the history of Sorrento, Mount Plymouth, and the surrounding areas for the benefit of posterity.

Scott Amey (right) is a longtime employee of the East Lake County Library. During his tenure, patrons have asked him about the history of the area. In 2008, he had a vision of forming a historical society. Amey held meetings and discussed his dream. After weeks of meetings, the society became incorporated on September 11, 2008. In 2009, Amey was presented with an honorary membership from first president Lester Weinmann.

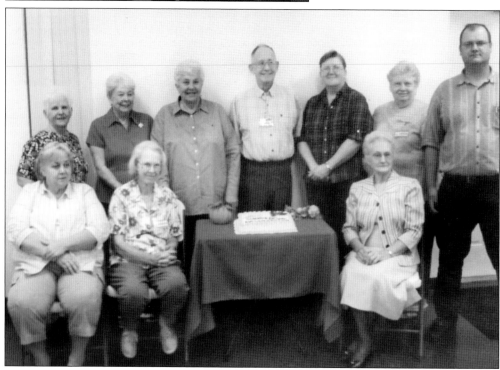

In September 2008, the East Lake County Historical Society elected its first board of directors. From left to right are (first row) Ann Bagwell, Barbara Grigg, and Shirley Meade; (second row) Frances Geddes, Dot Pegues, vice president Judy Boyd, president Lester Weinmann, treasurer Carolyn Green, secretary Maggie Fisher, and historian Scott Amey.

The East Lake Museum opened in 2014 at the corner of State Road 46 and County Road 437. The building was constructed in 1942 by George Raulerson. The Driggers operated a store there until 1970, and in 1971, Johnny Treadwell purchased the property. The museum contained five rooms with displays that featured schools and churches, the Mount Plymouth Hotel and Florida Central Academy, the history of Sorrento, the East Lake County region, and an office and meeting area. Maggie Fisher served as the conservator and Shirley Meade the historian. New building ownership in 2016 closed the museum. In the photograph above are, from left to right, Darrell Schroeder, Maureen Miller, Shirley Meade, Congressman Daniel Webster, Maggie Fisher, and Dr. John Driggers. Below, at a museum fundraiser are, from left to right, Barbara Tenney, Shirley Meade, and Darrell Schroeder.

The East Lake Historical Society hosts an annual Christmas party with lots of food, games, and entertainment to thank its members for their support. One of the most popular bands that performs is the Usual Suspects. Pictured in 2019, the band is, from left to right, Peter Mingay, Mollie Horton, and Sharon and Hank Link. The two guests at right, who joined in on a musical number, are Ashley and Josh Bruns.

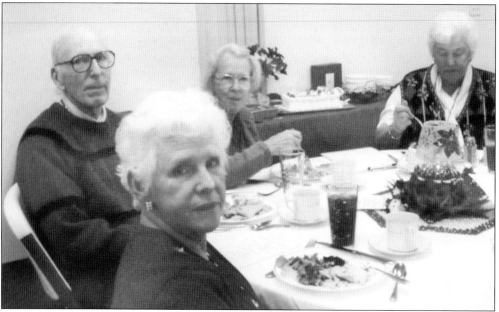

Pictured at the East Lake Historical Society's 2006 Christmas party are, from left to right, Frances Geddes, Tony and Barbara Grigg, and Judy Boyd. Geddes moved to Sorrento with her husband, Jim, in 1958. They raised four children, Mike, Lynn, Mark, and David. When the children were in school, Frances went back to college and graduated from the University of Central Florida. She taught school for 31 years.

Pictured are Judy Stone Boyd and Emory "Cub" Boyd in 2008. Cub, born in 1936, received his nickname from family friend John Ferris. Emory's father, Johnnie, had found a bear cub in 1936 while surveying for Wilson Cypress Lumber. He took the cub home as a pet after narrowly escaping the mama bear. The spoiled cub, which they named Bob, always wanted his milk bottle before newborn Emory got his.

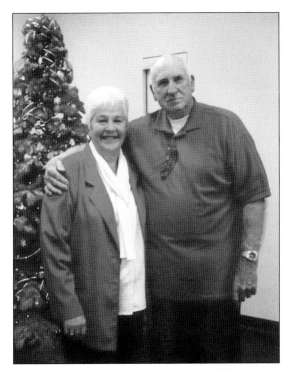

East Lake County Chamber of Commerce's 36th annual gala event themed "Back to the Eighties" was held on August 27, 2022. The gala was held at the Red Tail Country Club. That evening, the chamber of commerce presented the East Lake Historical Society with its 2022 Non-Profit of the Year Award. Attendees are, from left to right, Jerrid Kalakay, Deanna Kalakay, Tynell Miranda, Sherly Miranda, Pam Jenelle, and Steve Jenelle.

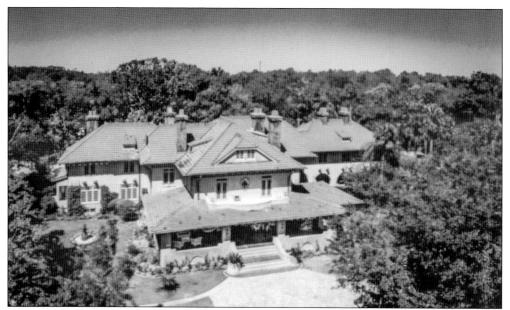

James L. Laughlin came to Florida wishing to build a hunting lodge. When he saw the view of Lake Minore in Zellwood, he thought it was the most beautiful place in the world. In 1890, he began building a 200-acre estate. By 1904, Laughlin completed the mansion (above), which he named Sydonie, in honor of his wife, Sydney. The mansion, designed by architect Grosvenor Atterbury, has 42 rooms and a two-story boathouse overlooking the lake. On March 13, 14, and 15, 2018, the East Lake Historical Society and the Zellwood Historical Society, along with the Tavares Community Theatre, hosted a "living history" tour of the mansion that included vignettes along the tour route performed by actors in period dress. Below, this Images of America page is dedicated to Margie Grinnell (second row, sixth from left), who passed away on September 21, 2022. (Both, courtesy of Harry Furey.)

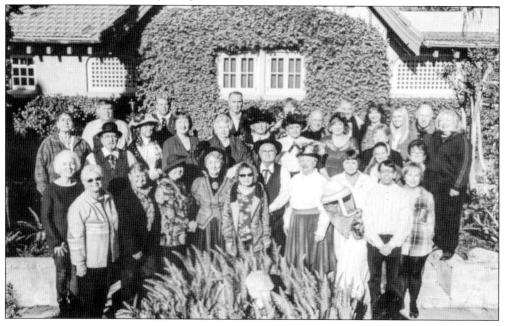

On July 8, 2014, at the East Lake County Library, the Declaration of Independence was read to commemorate the first public reading of the declaration in Philadelphia on July 8, 1776. Pictured are, from left to right, state representative Bryan Nelson, state senator Alan Hayes, Cindy Brown of Congressman Daniel Webster's staff, historical society president Barbara Tenney, librarian Scott Amey, Ralph and Kay Nelson, Commissioner Leslie Campione, and Sheriff Gary Borders.

The Sorrento Cemetery Association's annual Memorial Day event began in 2001. As of this publication, over 150 veterans are buried at Sorrento Cemetery. Through the years, this patriotic service gives special recognition to all the veterans with a special ceremony dedicated to at least two veterans interred at the cemetery. Flags are placed at all veterans' gravesites.

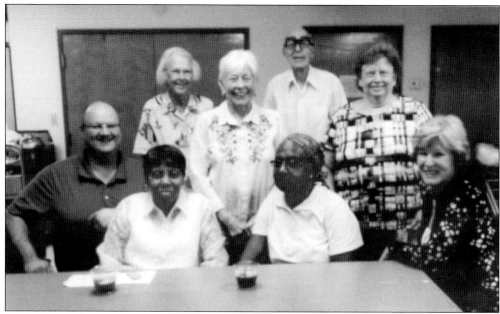

On February 24, 2018, Minnie Bollar (seated, left) and her sister Zethel Harvey Williams (seated, center) visited old friends at the East Lake County Library. Bollar was one of the first members of the East Lake Historical Society. With Bollar and Williams are, from left to right, Scott Amey, Barbara Griggs, Dot Pegues, Tony Griggs, Maggie Fisher, and Catherine Hanson.

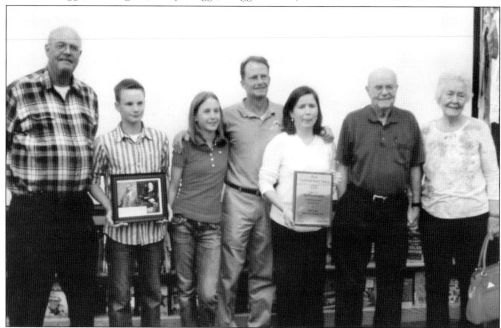

In June 2011, the Fransbergen family received the East Lake Historical Society's first Historical Home Award. The home was previously owned by the Rainey family. Pictured are, from left to right, Harry Rainey Jr., Lucke Fransbergen, Savannah Fransbergen, Ewald Fransbergen, Adriana Ibelia Fransbergen, Harry Rainey Sr., and Effie Rainey. The home on Rainey Road was built in 1886 by William Hawkins.

In 2015, the fifth graders at Sorrento Elementary School sponsored a fundraiser selling ice pops. They made $500 and donated the proceeds to the East Lake Historical Society to pay for three months rent of the East Lake Museum. Principal Brenna Burkhead is pictured presenting the check to Maggie Fisher and Shirley Meade.

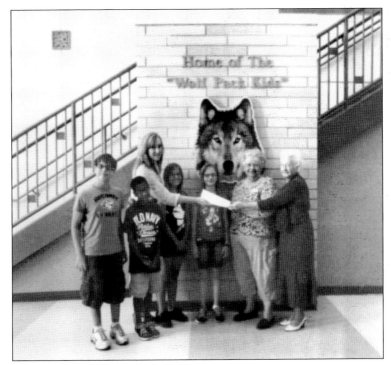

The Sorrento Wolf Pack Walkers from Sorrento Elementary School participated in the American Cancer Society's Relay for Life on May 6–7, 2011. The walkers demonstrated school spirit throughout the 17-hour fundraising event. The theme for the event was "birthdays," in honor of those who survived cancer. The event also remembered loved ones who were lost to cancer as well as those still fighting. School board member Jim Miller is pictured at far right.

In 2016, the East Lake Historical Society presented the I Made a Difference Award to Elizabeth Steele (seated), the youth events coordinator at East Lake County Library. Steele and other library staff created programs to reach out to the community, such as the Pumpkin Chunkin' Contest, Books on Board, PAWS therapy dogs, and "Meet and Greet Your LEO, EMS, and Firefighters" event. Pictured with Steele is society director Maureen Miller.

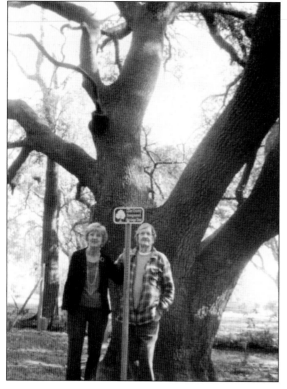

In 2011, a Southern live oak, *Quercus virginiana*, on the property of Nancy and Jack Williams, was designated a Lake County Heritage Tree. The tree met the requirements with a trunk circumference greater than 15 feet, a height of 60 feet, a canopy of 120 feet, and was at least 100 years old. County Commissioner Leslie Campione presented Nancy Williams with a certificate in recognition of the Lake County Heritage Tree.

East Lake Historical Society members Norma and Johnnie Jones volunteer at the annual Pumpkin Patch. The fundraiser set up by the East Lake County Chamber of Commerce benefits community-based nonprofit organizations. The event began in 2008 at the old East Lake County Library on County Road 437. In 2022, the Pumpkin Patch moved to the East Lake County Chamber of Commerce grounds on State Road 46.

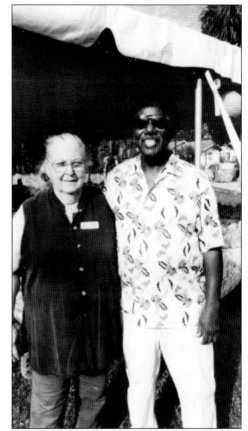

The East Lake Community Park began construction in 2011. With Sorrento's history of horse ranches and equestrian training, the design concept of the buildings reflected that heritage. The park consists of sports fields, basketball and tennis courts, and a children's playground. The complex is located on Wallick Road, near Sorrento Elementary School. The ribbon-cutting ceremony pictured here took place on May 23, 2013.

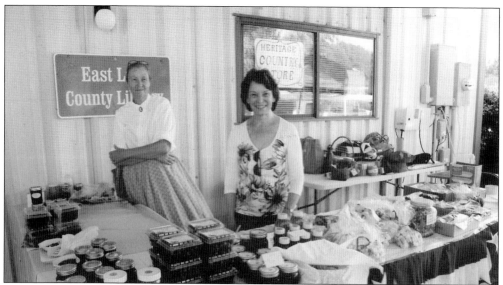

On Saturday, November 9, 2013, the East Lake Historical Society held its first fundraiser, the East Lake Heritage Festival. It was held on the grounds of the old East Lake County Library. The festival consisted of historical displays from churches, civic organizations, historical societies, the sheriff's office, the chamber of commerce, Camp Challenge, and Wekiva River State Park. Many vendors participated, and entertainment was provided by Blackwater Creek Bluegrass Band and Good Relations Band. The Mount Dora High School ROTC presented a heart-touching salute to veterans for Veterans Day. Above, Mary Cooksey (left) and Dorothy Curry (right) volunteer at the country store at the third heritage festival in May 2016. Below, Shirley Meade (left) and Marli Wilkins-Lopez (right) entertain the heritage festival guests in period dress.

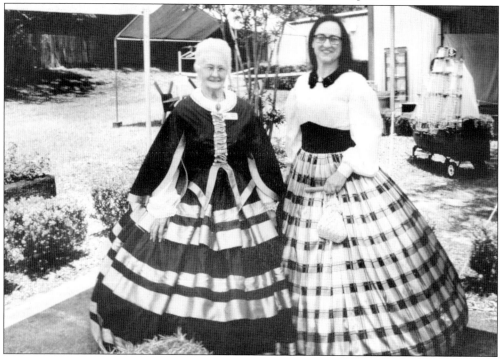

On May 16, 2015, the second annual heritage festival was held. The festival was set up as themed "villages." Villages included historical societies, natural history displays, American military history, civic organizations, local businesses, food vendors, and a country store. Don Campbell performed "The Star-Spangled Banner" a cappella. Blackwater Creek Bluegrass Band and the Dead River Band provided musical entertainment. Above, Civil War reenactors are, from left to right, drummer Jerry Peacock, Bret Gordon portraying Gen. U.S. Grant, Carter Zinn, Bob Grenier, and Don Campbell. Below, the keynote speakers are Congressman Daniel Webster (left) and Lake County property appraiser Carey Baker (right), a former senator and Iraq War veteran.

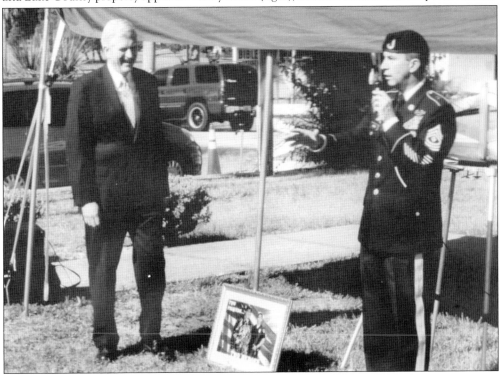

On April 12, 2014, the East Lake Historical Society dedicated Mount Plymouth Memorial Park, located at Troon Avenue and Dubsdread Drive. The event marked the preservation of the entrance (above) where the Mount Plymouth Hotel and Country Club and Florida Central Academy once stood. County Commissioner Leslie Campione presented a proclamation to the historical society. Stanley "Bud" Stokes, former head master of the academy, was the keynote speaker. A memorial plaque was erected that read: "Mount Plymouth Memorial Park, In Memory of Mount Plymouth Hotel & Country Club—1926, Fla. Central Academy—1959, Academy Closed—1983, Building Destroyed by Fire January 6, 1986. This Historical Entrance Way Preserved by East Lake Historical Society, Inc.—2011." Below, historical society board members at Mount Plymouth Memorial Park are, from left to right, Shirley Meade, Dot Pegues, and Maggie Fisher.

The above photograph by Bonnie Whicher, taken on September 8, 2022, at the Neighborhood Lakes Trailhead, features friends and families from East Lake County's historic past. From left to right are (first row) Sharon Treadwell, Pastor Earl Hammond, Bob Grenier, and Sam Musgrove; (second row) Fred Fritschle, Shirley Grantham, Frances Geddes, Buddy Fisher, Maggie Fisher, Amy Fowler, Lisa Martin, Rebecca Williams, Shirley Meade, Shane Meade, Nana Royal, Irene Rosenburg, Candace Willey, Joann Maynard, Teresa Fennell, Norma Jones, Johnnie Jones, and Maureen Miller; (third row) Harry Rainey, Martin Lieggi, Glen Treadwell, Scott Amey, Ryan Stormant, Christie Stormant, Mac Lantrip, Angela Lantrip, Ed Hansen, Frances Nipe, Pat Musselman, Bert Gnann, Robert Willey, and Albert Snyder. Below, the entire East Lake County family invites everyone to follow the arrow on the sign and restart this pictorial excursion of Images of America: *Sorrento, Mount Plymouth, and East Lake County*. (Both, author's collection.)

DISCOVER THOUSANDS OF LOCAL HISTORY BOOKS FEATURING MILLIONS OF VINTAGE IMAGES

Arcadia Publishing, the leading local history publisher in the United States, is committed to making history accessible and meaningful through publishing books that celebrate and preserve the heritage of America's people and places.

Find more books like this at
www.arcadiapublishing.com

Search for your hometown history, your old stomping grounds, and even your favorite sports team.